111
WEST COAST
LITERARY
PORTRAITS

PHOTOGRAPHS *by*

BARRY PETERSON

and BLAISE ENRIGHT

TEXT *by*

BC AUTHORS

INTRODUCTION *by*

ALAN TWIGG

111 ❧

West Coast Literary Portraits

MOTHER TONGUE PUBLISHING LIMITED
Salt Spring Island B.C. Canada

Library and Archives Canada Cataloguing in Publication

Peterson, Barry, 1945-

 111 West Coast literary portraits/photographs by Barry Peterson
and Blaise Enright; text by BC authors; introduction by Alan Twigg.

ISBN 978-1-896949-23-9

 1. Authors, Canadian (English)--British Columbia--Portraits.
2. Canadian literature (English)--British Columbia. I. Enright, Blaise, 1949-
II. Title. III. Title: One hundred and eleven West Coast literary portraits.

PS8131.B7P48 2012 C810.9'9711 C2012-902973-4

Book design, layout and typesetting by Setareh Ashrafologhalai
The text face is Amethyst Pro designed by Jim Rimmer (1934–2010)
Barry Peterson cover photo by Doug Kerr
Blaise Enright cover photo by Ron Garner

Mother Tongue Publishing gratefully acknowledges the assistance of the
Province of British Columbia through the B.C. Arts Council and the support
of the Canada Council for the Arts, which last year invested $20.1 million
in writing and publishing throughout Canada. Nous remercions de son
soutien le Conseil des Arts du Canada.

Printed and bound in Canada by Hemlock Printers

Published by:
Mother Tongue Publishing Limited
290 Fulford-Ganges Road
Salt Spring Island, BC V8K 2K6 Canada
phone: 250-537-4155
fax: 250-537-4725
www.mothertonguepublishing.com

MIX
Paper from
responsible sources
FSC® C014956
www.fsc.org

 *This book is dedicated to
the Beauty and Power of Literacy*

 CONTENTS

Introduction 1

Portraits, Prose and Poems 4

Biographies of Authors 227

Acknowledgements 251

Afterword 253

Index of Authors 254

 INTRODUCTION

IN THE 1950s, if British Columbians were asked to name one B.C. author, most couldn't. Authors were people who lived somewhere else. Or were dead.

Vancouver's only literary landmark was dedicated to the Mohawk "princess" Pauline Johnson, who lived on the West Coast for only the last four years of her life. Emily Carr had received the Governor General's Award for her first non-fiction book, *Klee Wyck* (1941), but she was not a household name.

Robert Swanson, who self-published poetry about loggers, was the province's equivalent of Robert Service, but his poems were far too popular among the working class to be accepted as literature. Outdoorsmen revered Roderick Haig-Brown, a lay magistrate in Campbell River who wrote about fishing.

A former Trotskyite at UBC named Earle Birney was trying to make a name for himself as a poet; much less conspicuous was a genteel novelist named Ethel Wilson who was married to a prominent physician in Vancouver's West End, but that was about as far as literary reputations went.

Whereas Eric Collier's Chilcotin memoir *Three Against the Wilderness* (1959) was republished by Reader's Digest and translated worldwide, almost nobody had read Malcolm Lowry's *Under the Volcano* (1947). Now ranked eleventh by the editors of Modern Library in their list of the best 100 novels written in English in the 20th century, the manuscript of *Under the Volcano* was completed on Christmas Eve 1944, when the tormented alcoholic was living in a squatter's shack at Dollarton in North Vancouver. Soon after Lowry died "by misadventure," in Sussex, England, his shack was unceremoniously bulldozed into oblivion in 1957.

(There was no love lost. Lowry habitually despised Vancouver, referring to it in his fictions as Enochvilleport, meaning "city of the son of Cain." Conversely, he referred to the tiny gathering of squatters' shacks on the foreshore of Burrard Inlet as Eridanus, a name drawn from the river in Virgil's *Aeneid* that waters the Elysian Fields of the Earthly Paradise.)

Probably the most esteemed B.C. author was *Province* columnist Eric Nicol, the first living Canadian writer to be included in *The Oxford Book of Humorous Prose* and the first local playwright to have his work produced by the Vancouver Playhouse. He was widely respected. He had a real job.

FAST FORWARD SIX DECADES.

The likes of Alice Munro, Douglas Coupland, W.P. Kinsella and William Gibson are world famous, and their success does not strike anyone as freakish. British Columbia is a literary hotspot on the planet. There are now more than 10,000 B.C.-related authors on the public service website abcbookworld, hosted by Simon Fraser University Library.

This incredible growth in authordom—from ten known authors to ten thousand—was not accidental. The rise of an indigenous publishing industry has been fundamental to the growth of authors. The golden age of growth in B.C. publishing can be marked from the formation of the Association of Book Publishers of B.C. in the early 1970s—led by J.J. Douglas Ltd. that evolved into Douglas & McIntyre, western Canada's largest publishing company—to the publication of the *Encyclopedia of British Columbia*, edited by Daniel Francis, in 2000, from Harbour Publishing, now the leading producer of regional titles.

So *111 West Coast Literary Portraits* is, in itself, a literary landmark of sorts. English novelist John Fowles wrote in his novel *Daniel Martin*, "To draw attention to anything is to glorify it." Just as BC *BookWorld* has been an undertaking to glorify B.C. books, *111 West Coast Literary Portraits* is an effort to glorify the people who create those books. I have therefore been pleased to support Barry and Blaise's work from the get-go.

When it comes to West Coast writing and publishing, we have gone from famine to feast in less than a lifetime. This unprecedented array of portraits celebrates the feast.

Barry Peterson's approach as a photographer is consistently unpretentious, attempting to serve both the public and subject, in an honest fashion. The fact

that his preferred technical approach is "non-digital" seems fitting when one considers the epoch to which our attention is being drawn.

As we move into this increasingly digital-based 21st century, it is hard to imagine someone producing a "real book" such as *111 West Coast Literary Portraits* twenty years from now in this pleasingly old-school coffee-table book format.

Just as many people are now fond of noting that durable vinyl records have a "warmer" sound than flimsy CDs, I hope others will agree there is much to be said for Barry's method. Or, as Barry puts it, "Film photographs have a sense of depth to them that digital images can't duplicate at this point. Digital images are printed on the surface of the paper while film images are printed on layers of emulsion in the paper. Even black and white offset printing can be a complex process that rarely duplicates the photo developed in the darkroom. Film and fibre-based prints have been around for 150-plus years, and many of the first prints are still around—and that was before they knew how to archivally process prints."

I remember when Barry and Blaise first arrived in my office. They wanted some help meeting authors. Yes, I knew a few. It evolved into a friendship. I provided some contacts, we named their exhibit Lit Happens and facilitated their first public showing at the BC Book Prizes, but they mostly made their own path, following their instincts. Now, with stamina and soft-spoken stubbornness, Barry has found a receptive publisher whose self-elected mandate is to champion under-recognized artists. Perfect.

Barry Peterson and Blaise Enright's mission to represent the array of authors in the province—not simply the stars, but rather a representative panorama—reflects and celebrates a golden era of literary expansion and cultural expression prior to the invasion of big-box stores, the ballyhooed onset of ebooks and the necessity of authors to turn themselves into self-referential bloggers. Those were the days, my friend.

Barry and Blaise are not effete. Instead, they have mostly wanted to be of service to the literary community. You can judge for yourself whether or not they have succeeded.

ALAN TWIGG
Publisher, *B.C. BookWorld, 2012*

2011

CAROLINE ADDERSON

"Falling," *Pleased to Meet You,*
Thomas Allen Publishers, 2006

That night the underwriter fell. He'd been standing at his office window working up the nerve to lean. Too late, he discovered the glass had been removed. Down he tumbled, yet it was not the terrifying sensation he'd assumed. He actually enjoyed the wind on his face and the attention gravity paid him, so confident was he that, somewhere below, the poem was there to break his fall.

2009

TAIAIAKE ALFRED

The Foreward to *Wasáse:
Indigenous Pathways of Action and Freedom,*
University of Toronto Press, 2005

To be Onkwehonwe, to be fully human, is to be living the ethic of courage and to be involved in a struggle for personal transformation and freedom from the dominance of imperial ideas and powers—especially facing the challenges in our lives today. Any other path or posture is surrender or complicity. And though I am speaking nonviolently of a creative reinterpretation of what it is to be a warrior, I am doing so in full reverence and honour of the essence of the ancient warrior spirit, because a warrior makes a stand facing danger with courage and integrity.

The new warriors make their own way in the world: they move forward heeding the teachings of the ancestors and carrying a creed that has been taken from the past and remade into a powerful way of being in their new world. In our actions, we show our respect for the heritage of our people by regenerating the spirit of our ancestors. We glorify the continuing existence of our peoples, and we act on the knowledge that our survival as Onkwehonwe depends on living the rites of resurgence. Fighting these battles in this kind of war, our nations will be recreated. The new warriors are committed in the first instance to self-transformation and self-defence against the insidious forms of control that the state and capitalism use to shape lives according to their needs—to fear, to obey, to consume.

When lies rule, warriors reveal new truths for the people to believe. Warriors battle against the political manipulation of their innate fears and repel the state's attempts to embed complacency inside of them. They counter-attack with a lived ethic of courage and seek to cause the reawakening of a culture of freedom.

Colin Angus and Julie Angus, 2008

COLIN ANGUS

Beyond the Horizon,
Anchor Canada, 2008

It was hard to believe that yet another tropical cyclone was heading our way. We had the worst hurricane season in recorded history to make our five-month, 10,000 km unsupported rowboat crossing of the Atlantic Ocean. Now, two months into our voyage, it looked very likely that our expedition might come to an abrupt end.

Our voyage across the Atlantic was a part of a much larger expedition: an attempt to complete the first human-powered circumnavigation of the planet. So far we had trekked, skied, cycled, canoed and rowed non-stop across three continents and were half-way across our second ocean. Now, as I huddled in the dog-house sized cabin with my fiancée waiting for the Hurricane Epsilon to reach us, I cursed myself for ever believing I could achieve such an impossible quest.

JULIE ANGUS

Rowboat in a Hurricane,
Greystone Books, 2008

At first I thought it could be the whale or a large dolphin. But the fin did not rise to reveal the curve of a dolphin's back or move in the slow manner that typified other visiting whales. Instead, it sliced through the water, a black blade cutting a straight line through the surface of the sea. I was mesmerized at what was undoubtedly our best shark sighting so far.

9

2011

CHRIS ARNETT

The Introduction to
*The Terror of the Coast:
Land Alienation and
Colonial War on
Vancouver Island and
the Gulf Islands,
1849–1863,*
Talonbooks, 1999

One aspect of British Columbia history which has not been examined in much detail is the alienation of aboriginal lands and resources during the colonial period, from 1849, when the Colony of Vancouver Island was established, to 1871, when British Columbia entered the Canadian confederation. The official policy of the imperial and colonial governments regarding aboriginal lands is fairly well known, but how this policy was enacted on the ground, particularly in the face of aboriginal opposition, is less familiar.

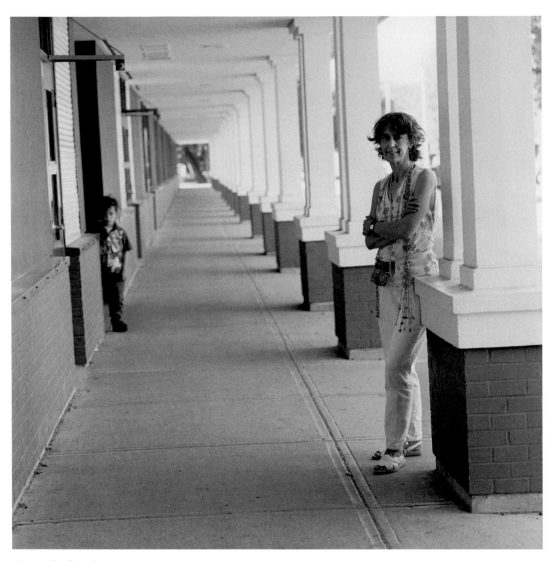

Jules Zenthoefer and Joanne Arnott, 2009

The Teaching

JOANNE ARNOTT

Included in *My Grass Cradle*,
Press Gang Publishers, 1992,
and *Mother Time*,
Ronsdale Press, 2007

I teach the chant to my son:
Earth, I am
Fire, I am
Water, Air, and Spirit
I am

He wants to know
how to spell:
"earth," "water," "fire,"
"spirit," and
"person."

1998

JEAN BARMAN

Growing up on the prairies, I dreamt of British Columbia. Totem poles and snow-capped mountains symbolized the west coast province. I fell in love sight unseen with this west beyond the west. Three decades of residence have not diminished the attachment formed as a child. British Columbia continues to fascinate, in part because it so often presents an enigma. Reality and perception, the geographical entity and its social constructs, Vancouver as a cosmopolitan city amidst one of the world's last frontiers—they all intertwine into a mysterious, fascinating whole that is British Columbia.

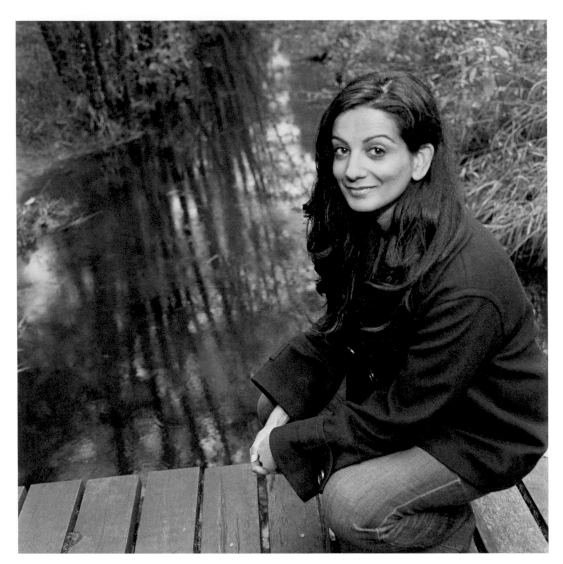

2011

GURJINDER BASRAN

Everything Was Good-bye,
Mother Tongue Publishing, 2010

I watched the light shift from blue to silver, the sunrise washed out by the layers of grey that stretched and collapsed all the days into one. Dark receded to the corners of my room. I hadn't been sleeping well. Each night I tossed and turned with the wind, measured my thoughts with the gusts of rain that rattled the windows and tried to sleep between storms. But even then, nothing. Nothing but the sound of the neighbours' mournful wind chimes and the sound of my mother's sleeplessness. She shuffled around, wandering from room to room, switching on and off lights, locking and unlocking doors. Sometimes I saw her cross the backyard in her shabby housecoat, a shadow among shadows, picking up strewn branches, garbage cans and pieces of newspaper that had been set tumbling through the night. When she returned to her bed, I'd hear her trying for warmth, the sound of her feet scratching against each other like the rustling of autumn leaves. Eventually she would settle and the only sound in the house would be the howl of the wind, the hum of the furnace, the holding of breath.

Evelyn C. White and Joanne Bealy, 2011

Nursing Home Haiku

JOANNE BEALY

1.
Mom in hospital,
Dad straight out of Cuckoo's Nest,
I can barely breathe.

2.
"What do I do now?"
Staring intently at her
hands on the counter.

3.
Pin the tail hoopla
sandbags, horse races, bingo,
ink blots, bland food too.

EVELYN C. WHITE

In all that I write, I aim to honour my African forebears. I pray that those who gaze at my image will recall the artistry of Bill "Bojangles" Robinson (1878–1949), the Black man who guided Shirley Temple through tap dance extravaganzas in 1930s-era movies. An acclaimed vaudeville performer, Robinson was routinely adorned in tails and a titled Top hat. Then came his pairing with Temple in which he showcased, in "The Little Colonel," his trademark "stair dance." At a time when Blacks battled soul-chilling bigotry, Robinson's performance in the film (and others) remains a marvel of grace and beauty.

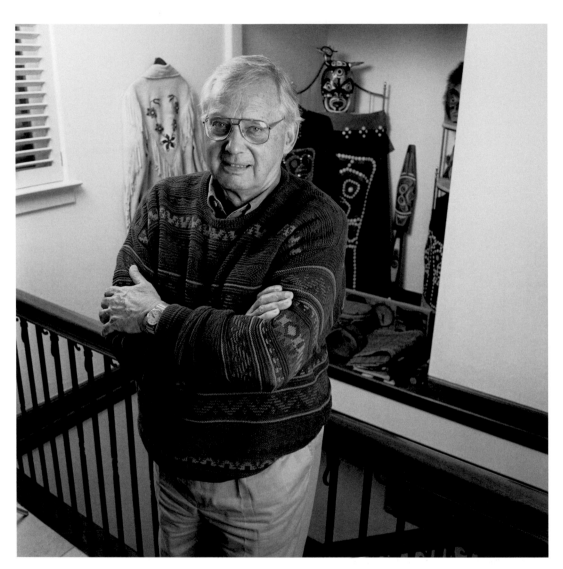

1999

THOMAS R. BERGER

Orwell once tried to explain "Why I Write." Each of us has our own reason, or at least our own excuse.

Writers may or may not be the unelected legislators of the world. But we do have an opportunity, if published, to offer an insight into, to illuminate in some way, a moment in eternity. We don't own newspapers, we don't have a media megaphone (and if we did the necessity of thinking of something to say on a daily basis would likely defeat us), but we can, perhaps, occasionally, shed light on a strand in the unfolding web of human experience.

Why else would we engage in such a solitary exercise?

1999

sout refuge in an abandond car

BILL BISSETT

outside uv waa waa hitch hiking in a blinding snow storm
 our hands frozn 2gethr sew did our lips whn they found us
n hosed us down we made a run 4 it well b4 spring brek up
 inishulee tho we wer on xhibit
as th best ice skulptyur uv th yeer th first time 2 men
 wer shown kissing in ice in wa wa n thn in kenora
wher we wer also displayd that town anothr hell 4
 hitch hikrs b4 we meltid n cud breeth agen
th full moon in april a huge hole in th sky th world
 cud fall thru

2011

ARTHUR BLACK

Looking Blackward,
Harbour Publishing, 2012

White water rafting in Alaska. Riding an elephant in Delhi. Galloping on a camel in Cairo. When Lou decides to do something, Lou does it.

Which is how I came to find myself decked out in a helmet and safety goggles, trussed into a diaper-like harness half way up a Douglas fir on a Vancouver Island mountainside. With Lou helmeted and diapered, right beside me.

We had spent half an hour bumping up the mountainside in Jeep 4×4's and the rest of the afternoon coming back down on zip lines, zinging, snakes-and-ladders style on a series of cables. Some were high—up to 150 feet above the ground. Some were long—over 1,000 feet in one case. All of them were quite "zippy"—they say we reached speeds of 65 kilometers per hour at one point. I wouldn't know. My eyes, like all other orifices, were clenched shut.

But Lou was right. It was thrilling—and eerily quiet, with only the zing of the zip line and the whistle of wind in the ears.

Oh yes, and the sound of Lou ululating like Pavarotti. I came whizzing in to the final stop whimpering quietly, curled in a fetal ball. Not Lou. Lou came in legs pinwheeling and chest-thumping like a superannuated apeman. All the other zipliners gave Lou a standing ovation on touchdown. Fair enough. Lou earned it.

Did I mention Lou is eighty-three?

Did I mention Lou's first name is Betty?

You go, girl.

1998

14 August, 2005

ROBIN BLASER

1925–2009

and I have! I hope - said
this is my silver day - now
make it golden - a walk,
a talk - a voice
 and it does
have a heart
 a chime
when gold sounds so dark,
so deep in the heart
of life - I hold you,
I told you life wanders
well-met - oh! I hope
I have told you

– for David

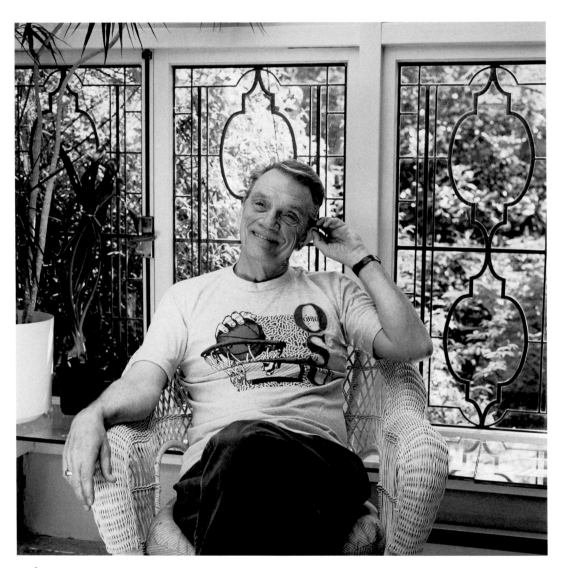

1998

Sitting in Vancouver:

GEORGE BOWERING

Vermeer's Light,
Talonbooks, 2006

Can I get a one-way
 to Squ'awsh, he says,
bus riders, words
 all over their clothes.

who the hell works here?
 offers hard-eye love
 at most

not a ghost in this place,
no real
 tracks, no smell of sausage

this train station's
 a museum, like
the notion of Calgary

Old people with vague
 north Europe accent
going to Kaslo, only reality
 I've seen. So there is,

but there isn't
 a train with
 my sister on it

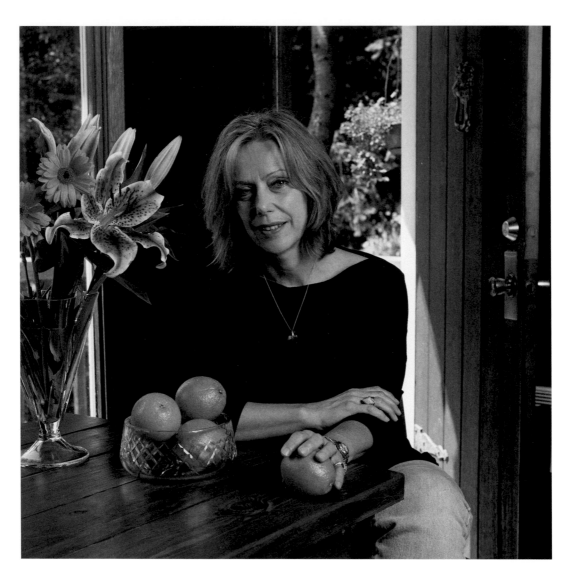

1999

MARILYN BOWERING

Part four, from the five-part poem,
"Space Talk," *Soul Mouth*,
Exile Editions, 2012

Is it poetry to talk
When nobody listens
Everyone knows what they feel
So what's the point
Anyone can pull up a soapbox
And pass the time
A poem is the weather
Its cold touches the bones
Its heat the genitals
Don't deny it
You look to verses and worse
When you're stung
Step onto this iceberg
And meanwhile we're together
Even though it's snowing
And winter will never end
When we reach the melting centre
That oasis of zygote
Just like we planned
There's a birth
No matter that I'm old
Not everything is about sex
Even this good cigar
For my birthday
Sometimes I just want to smoke
And remember Vesuvius
Before I stand too still
Freeze to death
This plate-form is moving
And I'm on it
Ice or raft or mechanical genius
It's all good company

2011

Tree, by Emily Carr

1932–22, VAG 42.3.63, oil on paper

KATE BRAID

PRISM international, 47:3,
Spring 2009

Stand back! This tree is going places!
It's a thunder of branches,
a wilderness of wind,
a highwayman riding, riding
through a stormy night, teamster's whip
as tree boughs whistle and lock
to the sharp brown shouts of cedar and pine
and there's the small green at the heart of things.

Notice how this tree doesn't fall but lays itself
down, gives itself when no one is looking,
for love, for a wild desire.

Night blinks wide in shock.
Moon blanches. Sky is a memory.
What is real is this—love unleashed,
an epic of tree trunk and limbs.

So ride on, ride on. Now we know
woodsmen only carry axes
to cut themselves free. Ride on!

1999

Paradise and the Woodlot

BRIAN BRETT

There's the wood for next winter's heat, and that's me at the chopping ground. It's lovely work, hopeless and unrelenting and ridiculous in this age, but we need several cords of wood for winter. Still, it's good labour. The imagination surges free when the blow strikes right and the world breaks. Then I dream against the grain—sometimes I dream I am both wood and maul. Yes, it's a joke, another mystery for the magic island where I live. Jokes and mysteries. I'm bemused. Wonder and laughter and sorrow. No one told me living in paradise would be such a struggle.

1998

BARRY BROADFOOT

1926–2003

The secret to it all is knowing you are going to be a writer when you're about 10. It may start then, or 10 years late or in the case of one great guy named McDonald he wrote his first and last book at age 75 and it is the best ever written about B.C. and Alaska and fish and fisherman. So there. It's this twisted gene or bent chromosomes you have within you. From the Golden Age of Greece to now no one ever learned to be a writer. It's just there. You can be taught tricks and twists and angles but if you ain't got it, goodbye Charlie. I remember my great friend the one and only Margaret Laurence telling me after she was a writer in residence at the University of Toronto for a year she had had 77 would be writers consult her and she worked with them and when I asked how many would make it she said, "One and I have hopes for another." That is just about right. Writing comes so easy to me I refuse to take it seriously which, on enough evidence, makes me a freak. Sweat, hell. Rewrite, hell no. Throw away. Very rarely. Very. Is it bad? Nobody has complained yet. Is it good? Please define good. Do people read it? Definitely yes. Then that's all you need to know. Is it satisfying? There's no life like it. But you have had to live that life to understand the previous sentence. And sadly, alas and alack, few do. Did I rewrite this? No. Writing time, 12 minutes because I had to think my way along, which no writer should ever do. And besides, this is a 1962 Underwood five typewriter, battered but still on its feet. Stolen from the Vancouver Sun when I quit in 1972 to write.

Terry Pollard and Anne Cameron, 2001

Banba

ANNE CAMERON

Again and again and again the sword rose and fell. Banba was chopped into smaller and smaller pieces, bits of her tongue were thrown to the birds, her eyes were gouged out and tossed to the fish, her entrails were strung out for the dogs and wolves and still the chopping continued until night fell and the one wielding the sword could not see.

The stone waited for the macerators to leave, and just lay there in the growing dark, missing the warmth of the place it had been living for so many decades and generations. Even before the powerful and vicious organized themselves to depart, the stone began drawing wet bits to itself, forming corpuscle by corpuscle, cell by cell, and had it not been almost pitch dark, and had the process been visible, a person might have thought the glob which formed was but a big clot of blood.

All the powerful nodded satisfaction. There was no song, now, no laughter, no noise, no mocking, no dancing, nor whirling, nor twirling, and they were sure they had won.

Except, in the morning, all the bits and pieces, the snippets and morsels, the blobs and the splatters had pulled themselves back together again, drawn by the power of the stone, and there sat Banba, unchanged, eating grapes and sipping clear water, making wine in her stomach, and her eyes challenged them.

So they did it again. From morning till night the great maceration continued, until it was too dark to see. And the following morning, there was Banba, with all her chunks and hunks and clots and slithery bits back where they belonged, and she was eating fresh-baked bread spread with rich butter, and she was laughing at them.

2011

My Father's Gift

NORMA CHARLES

My father's two old garden chairs languish out there, overgrown with periwinkle vines, in the jungle we call our back garden. He built them many years ago out of cedar and painted them reddish-brown, my favourite colour when I was a child. The paint's peeling now but the chairs still provide a comfortable seat when we watch the grandkids and their friends bounce on the trampoline, all rosy cheeked from the effort of becoming airborne. Or they kick around a soccer ball and shout, "Goooaal!" when the ball shoots between the two cones. Or they flick a birdie back and forth with badminton rackets. Sometimes we're even tempted to join them bouncing and kicking and flicking.

But mostly, it's lovely to sit back in the sunshine on my father's chairs and remember his generosity and humour. His crinkly eyes and his brief nod of approval.

It was his very last day, years ago, when I visited him in the hospital, bursting to show him my first novel. Lifting the book high, he turned to his room-mates. "I'd like you to meet my daughter. She's a writer, you know."

I still feel his loving pride today. What a gift!

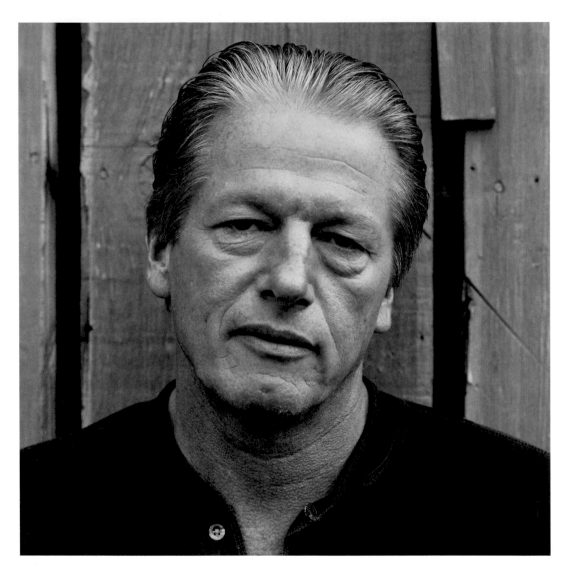

1998

JIM CHRISTY

Nine O'Clock Gun,
Ekstasis, 2008

There was fog and sunshine at the same time and
all but the very tops of the tallest buildings appeared
to glow from within like illuminated cotton candy.
And those very tops of those tallest buildings poked
through this spun-candy land and glittered in the
rare and magnificent sunshine. The jagged spire
of the Press Building shone so brilliantly, it could
blind a fellow or a gal, and the big red 'W' atop the
Woodwards' pile might be bloody prophetic. Sure,
this is the kind of day that comes around these parts
once in a blue moon but don't get carried away and
enjoy it too much because that 'W' doesn't stand for
Wonderful, nor Woodward's neither. 'Woe' is what
it really means.

Well, thought Castle, from the deck of the Santa
Lucia out of Lisbon, at the foot of Shanghai Alley,
here I am just back in town and already my mind
is going funny. Of course, it is a perfectly legitimate
way of seeing these things if one is the Old Testament
type. But your straight-line logic or your academi-
cian's version of truth ain't in it, which is what I've
learned over there in the Orient, Indo-China to be
precise, these last few months. Hell what the old
burg really looks like is a hophead's Kubla Khan. So
goddamned beautiful that, like any self-respecting
hophead him or here, I don't want to come down.
But they're waiting on me, calling: Come down,
Castle. Come down to these your tawdry streets.

2005

Jessie's Indian Room

MARIE CLEMENTS

Tombs of the Vanishing Indian,
Talonbooks, 2012

From the other side of a pane of glass, JESSIE, *age twenty-seven, sits at a desk in a doctor's office, furnished in white. She sets* THE MOTHER's *rock down on the edge of the desk. It stares back at her.* JESSIE *clears her throat as if beginning something important.*

She picks up the rock.

I dreamed once I had a mother and she had me, and I had two sisters, and she had them, and we were on a bus, with a skinny grey dog on the side, and my younger sister barfed on floor, and it smelled, and my other sister buried her baby face in my mother's deep breast and drank like that river was hers. I dreamed once I had a mother and she had me and I had two sisters and she had them and we were on a bus with a skinny grey dog on the side, and we were travelling a long way to make a new story, and it was hot and my mother opened the bus window, and a beautiful stream of wind came over us and it blew my mother's black hair all over our round faces, which lay on my mother's body like we owned her. She said just then, "Look, girls, look at those rocks." These three big boulders standing just so in the desert, staring just enough for us to recognize them. She said, "Jessie, look. Don't you recognize them from home? Look how they stand," and I said, "Yes, I think I do." She said, "Jessie, the rock family is following us to L.A., to start a new life too." Such are the things memories are made of.

2000

WAYDE COMPTON British Columbia's first black settlers came from San Francisco in 1858, fleeing political persecution in California. The first of them arrived at Victoria April 25, 1858 on the steamship *The Commodore*. While elsewhere the church has traditionally been a centre for black communities, small numbers and a transient population has made it so that in Vancouver the closest thing to a black community nexus has been the nightclub. The problem with nightclubs is that they close and re-open under new names faster than traffic lights change. But one club that links my generation to that of my parents is the Commodore Ballroom, which was open around the time my parents first met in Vancouver in the 1950s, and is still operating today. In the spirit of Ishmael Reed's clairvoyant historical synchronization, perhaps this is why the Temptations sang in the 1960s: "I can make a ship sail on dry land."

2011

CLAUDIA CORNWALL

At the World's Edge:
Curt Lang's Vancouver,
1937–1998,
Mother Tongue Publishing, 2011

There was something wizard-like about Curt. I think that in an earlier and less sophisticated time, a person like him might very well have been so regarded. A shape-shifter he was. Not only did he transform himself several times during his lifetime, but the people around him saw him in such radically different—wildly different—ways.

"Not much of a ladykiller," said Don MacLeod, a former bookseller who had known Curt in the sixties. Whereas his cousin, Denise Goodkey, who grew up with him, said, "He was quite a Lothario, you know." Bob Sutherland, an artist, recalled, "Curt did not have a great amount of respect for women at all." Yet Gill Collins, a girlfriend of his in the early sixties, said, "He was affectionate and tender." Nina Raginsky, a Vancouver photographer, also used the word "tender." She said, "Underneath that scruffiness, he was tender." Perhaps this was why Curt's brother, Greg Lang, said, "Curt could be catnip for the girls."

1998

LORNA CROZIER

Apocrypha of Light,
McClelland & Stewart, 2002

The plains are a mind thinking slowly

Though you're on the raincoast
and I'm back in Saskatchewan

it's you the plains recall,
the way you strode across the earth

when you lived that open, sky splitting
around your shoulders and doubling back

bicameral, long-winded. Day-dreamer,
you wouldn't have noticed if your feet

were wet or blistered like the rain.
Nothing here defeats you. Again, it's all

in the walking, lonely figure on a road
going West. This is how the great plains see you.

All that slow thinking that surrounds me
is thinking of you.

1999

WILLIAM DEVERELL

As I settle in to my "angulus terrarum" my quiet gentle corner of the world, I still feel a sense of displacement, of being a stranger in a strange land. It will take a time to adapt from the comforting sounds of night I am used to: the haunting lonely wail of sirens, jet engines in the sky, the distant screech of brakes, the city's ceaseless hungry hum. Instead I must endure an annoying swish of waves upon my beach, the incessant gossiping of the little green frogs that inhabit my pond, the cold-hearted inquiries of the distant hunter owl. I awake not to the alarums of a garbage truck in an alley but to the impolite nagging of song sparrows trilling their tunes of the unfolding spring. Ah, but I will overcome these frowns of fortune. "Nil desperandum." I will prevail.

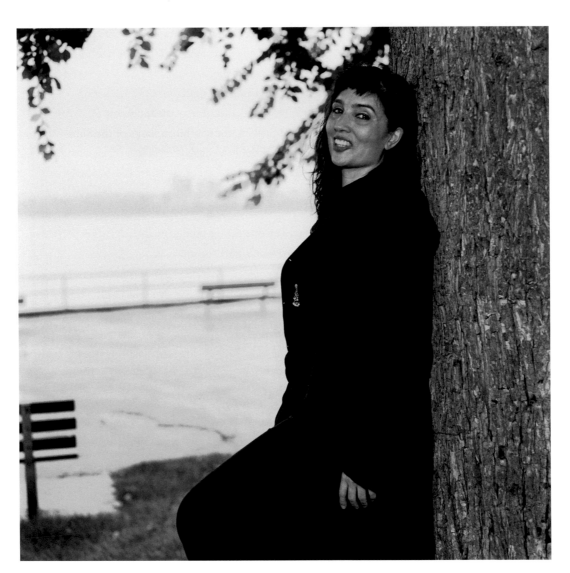

2011

HADANI DITMARS

*Dancing in the No-fly Zone:
A Woman's Journey Through Iraq,*
Interlink, 2006

The faces of the children came back to me, the sounds of Karim's cello playing Ave Maria, the scenes in the hospital, the street kids, the soldiers at the al–Rashid, the dark corridors of Abu Ghraib, the cruelty of friends and the kindness of strangers, promises kept and broken, the soothing chants of the Sufis, Haidar's lead-footed angels.

I barely made it on to the tiny plane as a huge crowd of Iraqis and foreigners jostled for position in the wildly snaking queue. This time my seat mate turned out to be a special forces man who had once dreamed of becoming an opera star. Flying over the land that I had come to know and love, urban traces slowly gave way to vast desert expanse. As I stared out at a broken nation, its distant landscape turned luminescent. For a moment it sang with light.

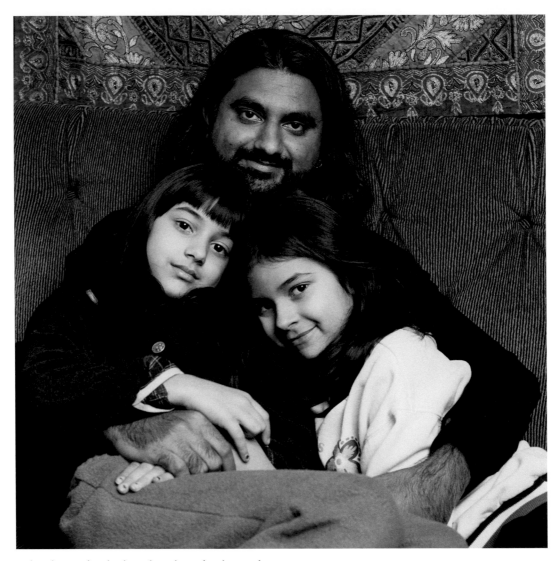

Nadya Cleary Dulai, Phinder Dulai and Natasha Cleary Dulai, 1999

To Listen

PHINDER DULAI

Basmati Brown,
Nightwood Editions, 2000

Shards of Qawwalli, tablas maestros
bea (dhin)g te rhy (dhum) out
We listen
Nadya and Natasha and Nusrat songs.

I remember each one circled in my arms
running their small bodies through rhythm
held them tight to my heart
each one a new beginning, fingers to fingertip.

We are circles, joined hands
everything possible, nothing failure
catching the clapping hands
Our hearts pulsate on one rhythm
Dancing, smiling at each other
we culminate with the finale
we break, I fall on the couch
with their hair in my mouth
and face.

1998

urban intermezzo

MARILYN DUMONT

Napier
(formerly *Green Girl Dreams Mountains*),
Oolichan Books, 2001

workers are dragging home to supper and the cafes are empty:
the ceilings high, the fans apparent, the music filling the spaces
where the big-mouthed diners sat before. Guitar sounds echo off
egg-shell walls, and the stacked tins of artichokes, tomatoes and
olive oil. Now the ceiling fans clear out the day's chatter, the
coolers hum to themselves and I watch the day's stragglers lug
their stretching bags home and finally the street cools in the
memory of mothers & strollers, squeaky buses, ninety-nine cent
pizza diners and shaved, pierced and tattooed x-ers.

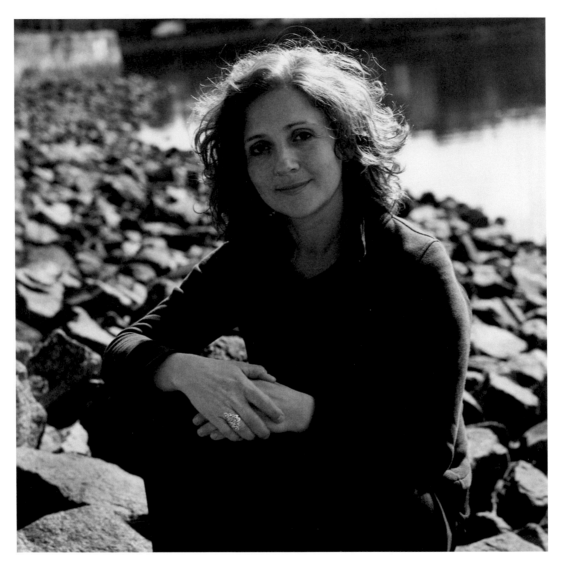

2011

the weight of dew

DANIELA ELZA

the weight of dew,
Mother Tongue Publishing, 2012

can I fill these words with what is not

intended. with what the river keeps
hidden

 under her tongue.

with the maps birds carve in my marrow
fill my bones with air
my eye with their dying.

to wait on the river bank

 long enough

to know what knowing looks like
before it is disturbed.

stepped on. sanitized.
poked with a stick.
put in a vial.

to know the shape of me

nameless— my given names left out
like shoes I was meant to fill.

they gather dew now

it slides down their tongues. I watch them
through this open door where

even the clock wipes its face clean.

2009

Author Interview

M.A.C. FARRANT

Down the Road to Eternity:
New & Selected Fiction,
Talonbooks, 2009

1. Thank you.
2. Sure. Appears to be. But isn't.
3. Five of us, actually. Though everyone's left. Except us.
4. School. Work. One to a nursing home.
5. That's right. Two of us in this big house.
6. Not bad. I write. He cycles. We visit the others.
7. Oh, every few weeks.

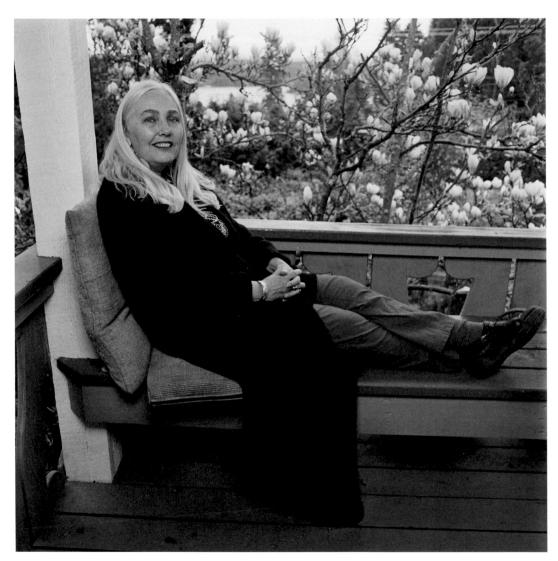

2012

MONA FERTIG

"This is Paradise,"
two of fifteen stanzas,
The Unsettled,
Kalamalka Press, 2010

This is Paradise,
But the Optimists are tired, the dreamers who drifted
here as Hippies have grown old. Their children have
left for the Mainland to seek their fortune. Taken the
ferry & cellphone. Old activists braid garlic.
Enter pies in the Fall Fair.

> *Deer slip through dusk like island widows.*
> *Villagers take refuge in singing or solitude,*
> *Party at potlucks or lament over Change & Progress.*
> *The Pessimists go home early, champion themselves,*
> *call 911.*

This is Paradise,
But clear as the New Year, the dirt yard has been raked.
The chickens locked away. The house. Not to code,
is cozy. Inside, beside Buddha, beeswax candles burn.
Pea soup simmers, organic, no ham. Love is safe,
curled like a raccoon.

> *She once made batik curtains, dresses, sold poems & pottery.*
> *Walked barefoot in the city, now her hair acquiesces; short,*
> *she nurses the dying, reads through a pyramid of books,*
> *arthritis is mean.*

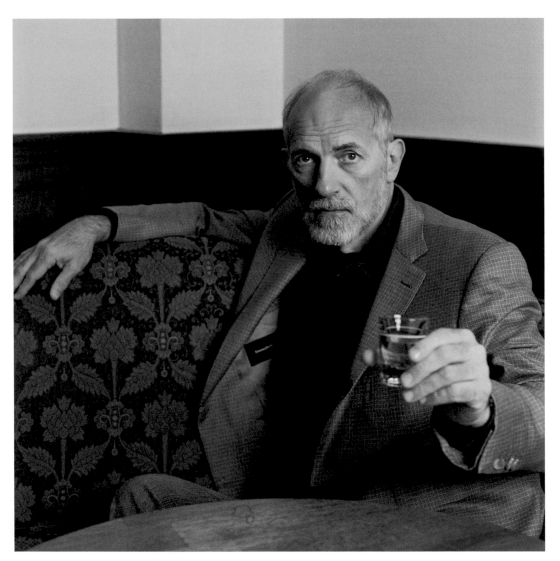

2011

Hangovers and Regret

GEORGE FETHERLING

The Sylvia Hotel Poems,
Quattro Books, 2010

I can't be blamed for failing
to learn the unknowable
neither can you fault me for wishing.
The only reason I drink all this wine
is that it lets me think of you more clearly
you're not the sort of person who puts
up with any nonsense from me or Nature
the power you have is warm but it is
power you do not want over someone
you dare not acknowledge.

I despise the expanse you keep between us
that slowly fills up with the past
like never-ending invisible snowfalls
silent comforting suffocating cold
methodical until they turn lovely
frostbite and exposure resulting
from hangovers and regret.

I keep watch on your window
so burn a red candle if you agree or
merely understand that we cannot
wash the truth out of ourselves.

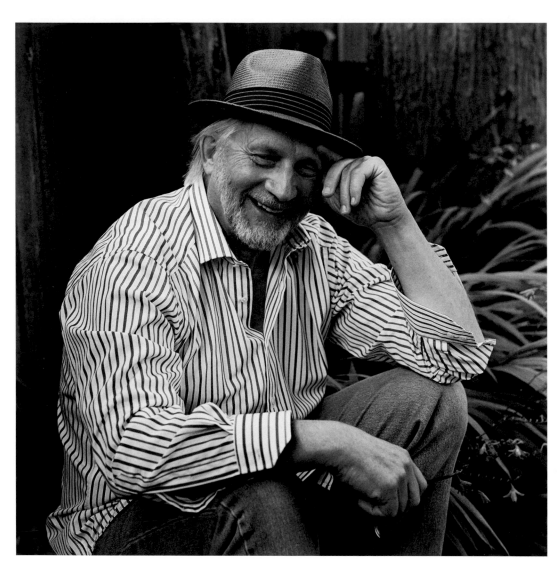

2011

PATRICK FRIESEN

A Dark Boat,
Anvil Press, 2012

telling time by the dog among the tulips

you have a corner of garden
with montbretia and prairie grass

there are days you tell time
by the gardens in your life

or perhaps by the dog who slept
in a hollow among the tulips

while you are on earth
it is difficult to believe in absence

what you remember is a door
through which you entered

some arriving horizon
a place to set yourself

2009

Quarks

MAXINE GADD

"Boatload to Atlantis,"
in *Subway Under Byzantium*,
New Star Books, 2008

black bear on mcgonical,
buzzy turn into
sloe-eyed harpies with me or against me
i'm not grieving
get the best of the telephone dregs
can't live without
punctuation

imagistic satisfaction a track in the ancestor's hovel
crass, bad
life affirming personables,
the plot drops off a rotting tree highway crash,
no, i don't want to know,
let's choose that valley full of cherry pits,
organize chap, cackle yu drab

a limit to the terrible rush of two thousand pound herds
comets concupiscent of becoming planets,
quarks / the occurrence of laughter
a shy up and down
gormless takes

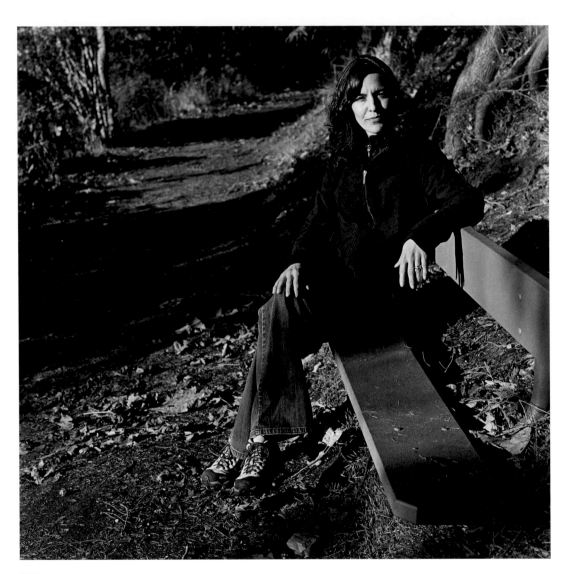

2011

CHARLOTTE GILL

Eating Dirt,
Greystone Books, 2011

Planting trees isn't hard. As any veteran will tell you, it isn't the act of sowing itself but the ambient complications. It comes with snow pellets. Or clouds of biting insects so thick and furious it is possible to end a day with your eyelids swollen shut and blood trickling from your ears. There are swaying fields of venomous plants like devil's club and stinging nettle. There are sunburns and hornets. There are swamps rimmed with algal sludge to fall into up to the armpits. There are leeches and ticks, bears and cougars. There are infections and chafe and boils and trench foot. It's possible to be so cold you feel dreamily warm and so hot you fall into shivers. Over time the work has the bodily effect of a car crash in extreme slow motion. Sometimes our bosses make off to Mexico with all the money. Besides that, the task itself is thankless and boring, which is to say it is plain and silent. It is also one of the dirtiest jobs left in the modern world.

What could compel a person to make a career of such a thing? I have always wanted to find out.

2009

TERRY GLAVIN

'The Singing Tree of Chungliyimti'
in *Waiting for the Macaws and
Other Stories from the Age of Extinctions*,
Viking Canada, 2006.

Making our way through the mountains, passing bamboo-thatch villages and groves of pineapple and genari trees, even the road signs were odd. *After Whiskey, Very Risky. Then Not Safe To Travel At Night. Then Assam Rifles, Friends of the Hill People.* Then Safety First, Speed Next. We roared on through the village of Medziphema, and then through Zubza. As dusk was falling, women were streaming out of forest paths and onto the roads with stacks of firewood on their heads, and chickens raced out of our way. I called Neisatuo's attention to the *It Is Not Rally Enjoy Valley* sign, but what followed after that one was *Don't Gossip, Let Him Drive.* So I spent the time quietly puzzling over *Self-Trust Is The Essence of Heroism* until we reached Kohima, 70 kilometres into the mountains above Dimapur. It was long after sunset, and after Kohima, there was just that last, grinding, hourlong backroad ascent through the night to Khonoma, the Angami citadel. I was finally through the looking glass.

When I woke up the next morning I could have sworn I was in Machu Picchu.

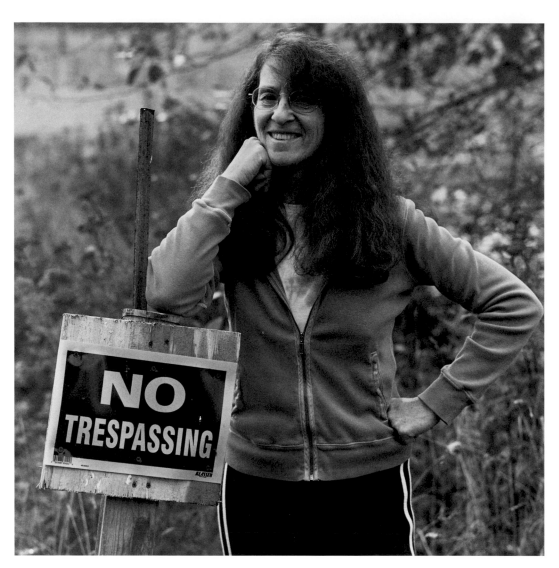

2011

KIM GOLDBERG

"Night Was a Vacant Lot,"

Night was a vacant lot with a secret
Day was a waffle with blueberry jam
Each lost job, a new bed in the bracken
Nobody knows how to dial a phone

Day was a waffle with blueberry jam
Night was the raccoons screaming again
Nobody knows how to dial a phone
Let's go watch the white-suited men

Night was the raccoons screaming again
Collecting her story with purple gloves
Let's go watch the white-suited men
Brushing fine residue into their jars . . .

Cheryl Lynn Sim, a 53-year-old aboriginal mother and grandmother, was murdered and left in a shopping cart in this vacant lot at the end of my street. Neighbours said they heard wild animal screams. Cheryl had been living on the streets since losing her restaurant job earlier that year. Approximately 300 people live and sleep on the streets of Nanaimo.

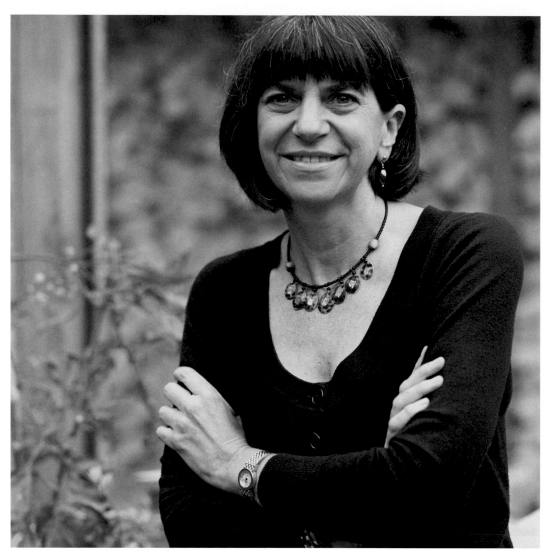

2011

Sandwell Beach, 1.15 p.m.,
April 22, 2007

KATHERINE PALMER GORDON

"Landed Immigrant,"
Imagining British Columbia,
Anvil Press, 2008

Nothing ever seems still on the exposed landscape of the beach. There is no surcease from the scurrying wind and the static rumble of the waves. Except, perhaps, at that pause as low tide hangs in the balance; the sea leaning away from the land until the moon beckons it to begin its changeless dance back towards the shore once more. At that single moment in time, conceivably, the wind drops for the beat of a heart; the waves lie still for as long as it takes the second hand of a watch to make its staccato move from one mark to the next; and all is hushed . . . until the breeze begins to doodle tantalisingly on the surface of the water, the cry of a gull skitters through the air, and the waves throw themselves once more at the sand.

Tomorrow's rain is promised in the high, hazy, cirrus clouds reaching slowly across the sky. Salt-laden mist will compete with the Spanish moss, circling through the treetops, and fat raindrops will drip on the skunk cabbage and wild roses. The sea will become grey and opaque, and the offshore islands will disappear altogether.

But today, it is sparkling and vivid and glorious in the sun, on the rocky shore and windblown sands of this little island, on Sandwell Beach: on this headland, as the gulls cry above, in this place on the edge of the Pacific Ocean that is my home.

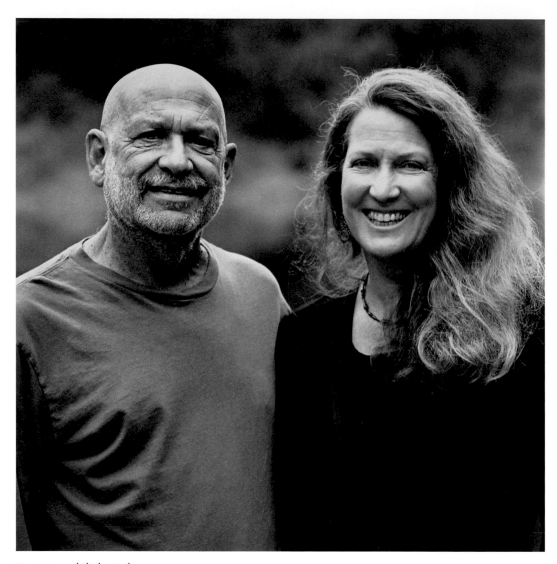

Peter Levitt and Shirley Graham, 2011

Chair at the World's End

SHIRLEY GRAHAM

What Someone Wanted,
Black Moss Press, 2007

It faces oblivion
with it's back to the forest,
the same forest that's been encroaching
for thousands of years.
An elegant chair, its simple lines
call to you from any distance.
Once in range, it invites you to sit
on smooth curves and contemplate nothing.
When you sit, it steals your watch,
pen, notebook, and long-term memory.
You'll have an impression of things floating
past you, out of reach.
The chair never moves and in no time again,
it is empty.

PETER LEVITT

One Hundred Butterflies
Blissful Monkey Press, 2011

Children dance
around the bald skull
of this mountain.
Here, where nothing can survive
laughter never ends.

1998

Flamenco

R.W. GRAY

Crisp,
NeWest Press, 2010

Listless Thursday, a clutter of old men at the back
bar watch sports they've never played on mute
screens. Nearer the small square of stage, the table
loungers lean famished and bored. She sits poised
against the wall, her eyes cast down on the stage
spreading out around her feet. The man with the
guitar, his dark hair falling over his face, oblivious
to her, but he knows what comes next despite her
slanted repose. A woman waiting.

She's pulled to her feet like she's already lost this
tug of war, the crack of her heels, the wood floor run
smooth and tan where other women like her have
eroded the black paint away. Our glasses half full,
the waitress folding paper napkins, the bartender
watching soccer on a small TV below the bar.
Drowned faces in passing cars wash down river, see
her on this tired small stage, see her with her arms
above her head, her face now thrown back.

The old man singing doesn't know he's old. He
sings like he did when he was 21. It's all he can do.
All he can do not to think about later and the empty
chairs. Not even a forgotten purse to ask him what
the words mean and who he is singing for.

In that skinned open space between tables her
hands ignore her face as they unfold origami the
closed mouths of birds, her arms all slender throat,
reaching up, above her now, high above the floor,
her hands face then turn away. Equal parts want
and beleaguer.

My phone rings, you calling, so I take it out to
the street. It's a poor connection, the kind where after
every word I say echoes back. It's impossible to love
this way.

Amanda Hale and Darby, 2008

Señora Amable Ponce

AMANDA HALE

In the Embrace of the Alligator:
Fictions from Cuba,
Thistletown Press, 2011

Señora Amable Ponce opened the door wide. I was immediately riveted by her eyes, and only peripherally sensed the grand entry hall. There was no doubting her identity. Spanish to the core, her dark eyes smouldered with the history of a people conquered and dominated for centuries until the tables turned and the Moors and Jews could be driven out. No matter that their blood was by then irrevocably mixed, the Spanish would be masters in their own house, as was the Señora, *la dueña*, ushering us in with a languid gesture.

It was a minute or two before I noticed her wounded leg, the crutches, her shrunken body, and by then I had already a firm impression of grand stature and fortitude. She had held me with her burning eyes, her red lips, the elegant gestures of her hands, and now she was forever indistinguishable from the grandeur of her family home.

She turned and led us, limping slowly across the expansive salon and down a wide corridor to our room. Before opening our door the Señora pointed to a terrace spilling over with bougainvillea, the petals airborne like a cloud of butterflies. A table was set with green plastic mats and a condiment set. Would we like dinner? She could offer chicken, pork, prawns, as we wished. We settled on prawns, and Onaldo asked for beer. She called and a young woman appeared, wiping her hands on her skirt. Her head was wrapped in a turban and she had strange watery blue eyes, almost crossed, filled with a wounded light. Her mouth was soft and open like that of a baby.

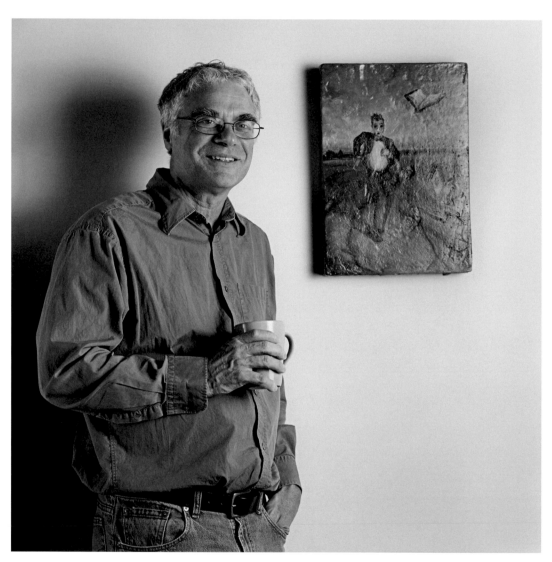

2008

KEITH HARRISON

My shadowed self stands next to "Open Book," a painting by David Kilmartin. Because the perspective keeps changing, it's not clear if the swerving runner pursues the book or if the winged volume chases after him. I prefer the notion of agency, a conscious energetic pursuit, but often it seems the book catches up—as either threat or promise (perhaps a belated Muse offering inspiration). Either way, the next novel is about to crash into my skull.

2011

Vesuvius Bay, Winter

DIANA HAYES

This is the Moon's Work,
Mother Tongue Publishing, 2011

I go down to the bay at dusk in winter,
in a strange skin not fish or woman,
and let my body walk away
from its life.
This moment here, that moment gone, no matter
that alarms ring, the mornings struggle on.
I walk into the sea with great relief
that my earthly self will not stare back at me,
that my skin, now electric with salt and pure cold
brings me to a wilder place of belonging,
in the company of seals and starfish
all eyes and whiskers, all rays of tangerine and mauve.
Here I sing to the great Neptune of this wet sanctuary,
 I am here, I have arrived
 without burden or restraint,
 ready to swim into my life
 now clear, no cloud or fear, nor loss.

2011

Shaped by the Wind

ROBERT HILLES

Wrapped Within Again,
Black Moss Press, 2003

We drive north of Carbondale Lookout
and pass trees shaped by the prevailing wind.
Beneath the surface history grows
and the earth collects each thing that dies
willing to hold all that time has let loose.

Pine trees lean east as if in motion
caught mid flight like fleeing animals,
except, unlike us, trees and plants
are joined to the earth
by restless roots
grasping dark soil.

You drive briskly
and lean over to squeeze my knee.
You say I love you,
and I forget history boiling beneath us,
forget the birth of coal,
think only of your warm hand,
as it seeks
the soft spot above my knee
pushing gently
like a root taking hold.

1998

JACK HODGINS

I'm not sure I know the line that separates myself from this island. Perhaps it doesn't exist. A stand of second-growth timber, a beach cabin, a weathered barn, a country store, a float house, a sprawling mansion, a row of specialty shops, a rusting hay rake—around every corner there is an image that suggests something more: humans in a place, a community, a story.

To ask "How did we come to be here?" or "Why are we still living here?" is to call up stories of dramatic shipwrecks, devastating forest fires, frightening earthquakes, endless rain storms, repeated mudslides, bizarre family feuds, and utopian colonies in ruins. These stories are more likely to be told with a mock-heroic rather than tragic slant. Our folk songs, if we had any, would celebrate giants of the woods, women who fought off cougars, and weddings so exhausting they ended up doubling as funerals. This landscape provides all the metaphors anyone could want for making a stab at understanding life.

2009

PAULINE HOLDSTOCK

Into the Heart of the Country,
Harper Collins, 2011

No one told me the vastness of the land. That when a person walks out the horizon is always farther and still farther and no amount of walking will bring it near. When I was a girl the horizon was the place the Wêcîpwayânak came from and the Kisiskâciwanak. A place a man could walk to as Samuel did and see there the Far-off Metal River and the Frozen Sea and come back and tell it. I did not expect the horizon to walk away from me. The vastness of the land was beyond my imagining. All my world was the fort. Its walls contained all that I could need and until Samuel left all that I desired. It was my home. Why would I desire ever to walk away from it? Why would anyone leave her home unless to be with her husband?

And yet I did leave and I did discover the vastness. So that it was as if my own life's purpose after all was to supply an answer to the question I believed required none. As if all my life had been only a prelude. All our lives only ever a prelude to what is to come.

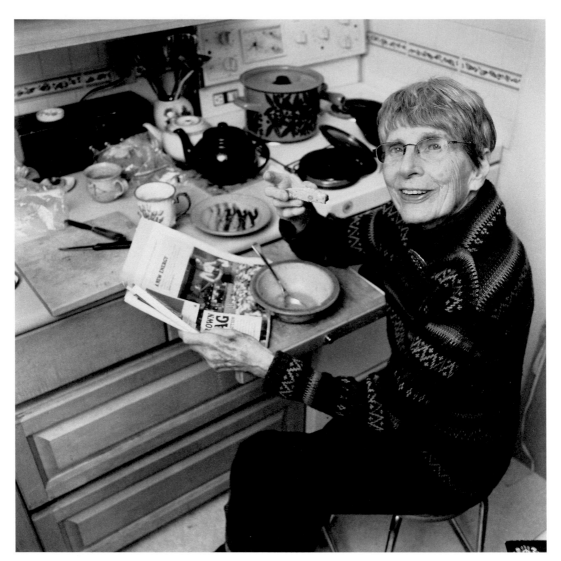

2011

IRENE HOWARD

"The Norns, the GTP and
her Beautiful Black Hair,"
in *Gold Dust on His Shirt:
The True Story of
an Immigrant Mining Family*,
Between the Lines, 2008

What was she thinking as she picked her way
through the mud, carrying me, nine months old?
It had been twelve years since she had left Norway.
Inga was now fifteen years old. A mother should not
abandon her child, but that is what she had done,
though she had not meant to do it. Things had not
worked out as she had planned. She shouldn't blame
herself, it seemed like fate, an evil Norn intervening
over Inga's cradle. Was this the price she had to pay
for daring to leave home, for finding a new husband
and a new life?

But her hair, her beautiful, black hair! That was
her own doing; no willful Norn had ordained that
she cut her hair.

After a while the horses emerged from the mud,
the road became drier, and she climbed back into
the wagon. My Ingeborg, whom I've re-created out
of fragments of memory and out of bits and pieces
of historical research and whom I now think I know
and understand, my Ingeborg puts her hand to her
neck to feel where her hair had been, and the tears
come. Whether she weeps for Inga or for her hair or
for vexation at the mud and mosquitoes, she does
not know, and I do not know, but even as I write
I weep with her.

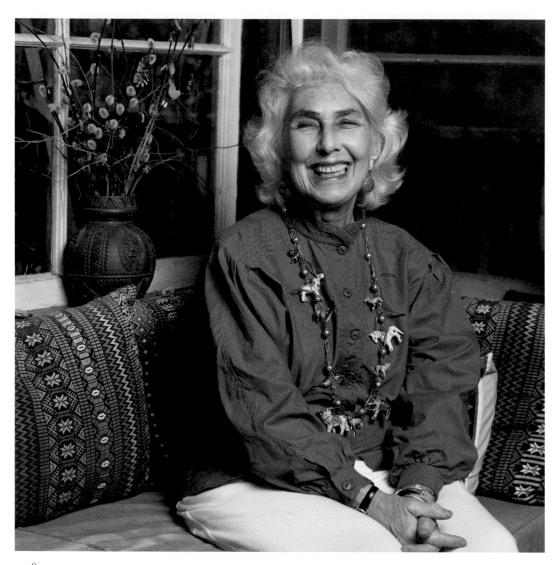

1998

EDITH IGLAUER

When I was very young, my father told me to always smile, because I looked so gloomy when I didn't. As I grew up and saw serious photographs of me, I realized that as usual, he had given me excellent advice. But I have every reason to smile! I have a fascinating and happy life, and a great family; wonderful sons and their wives, and two glorious grandchildren. I live in a gorgeous part of the world, cherish my friends, and I am still writing and being published. Why would I not smile?

Rick James and Paula Wild, 2008

RICK JAMES In 1992, the Victoria Times Colonist published a story I wrote on retired sailing ships that had been cut down into barges in the 1920's and 1930's. Accompanied by old photographs, the story looked fabulous.

But within a few days I received a letter from Bent Sivertz. It stated: "As one writer to another I have taken the liberty of amending the odd phrase or construction in your article." Bent knew his stuff since he'd sailed on one of the ships in 1922–23.

Now I look back on that incident with fondness. Bent was a fascinating old salt, and I learned a lot from him. He also became a great friend. So, in the end, that letter proved far more rewarding than the cheque I received from the newspaper.

PAULA WILD The writing life is a quirky one. You can work in your pyjamas. You accumulate a lot of paper, and you get used to asking perfect strangers absolutely anything—and having them tell you everything.

Receiving a grant to research rotting fish was odd - discovering I didn't mind the smell even more so. I've been warned by RCMP to make a certain interview the last one I conducted before leaving town. And once I was thrown out of a museum.

Living with another writer is a bonus. We discuss story lines and edit each other's manuscripts with millions of miles of red ink. And on occasion, Rick has filled the role of photographer, chauffeur, and even body guard. Every story is an adventure.

2011

The Conversations

SANDI JOHNSON

The Conversations,
a work in progress

Life consists mainly of thoughts. Private, mysterious, thoughts are happening all the time. Until thoughts are spoken we don't know their nature or intention.

In the theatre everything is false and everything is true. Theatre creates a dramatic experience. We understand it isn't real.

Conversation creates our reality. When thoughts are finally spoken they have physical properties that touch people. They have the power to both connect and separate human beings. Conversation happens in the particular light and background noise of the present moment. Words touch; they make impressions, they cause emotion, moving people to laughter and tears. Delighting, offending, conversation makes people act and imagine.

Like seeds growing underground, the unseen, the invisible is where growth and change are really happening. Look at that man and woman having coffee, engaged in conversation. We can't see energy vibrating between them; we can't see the pictures lighting up their brains. They might be bonding, but bonds aren't something we see.

People at a bus stop are passing the time of day. Look in that restaurant window. Men and women are having dinner conversation. Who is that man sitting on the park bench, the one wearing the navy watch cap? If we say, *nice day isn't it*, he might tell us his story. We only know what he tells us; we remember what's been said.

The universe is humming with what's been said. The trees and the rocks hear this. Conversations are going from person to person, walking all over the world.

2011

At the Sylvia

EVE JOSEPH

All day and night
I fought sleep.
Rain falling in another city
Woke me.

At dusk I watched the single-minded
Evacuation of crows
Between apartment buildings,
Over red rooftops, dark scouts
Pressing forward.

The mystery is not in things
Leaving, it is in the miracle of their return:
Morning finds the crow back in the tree
The room portioned into five lookouts.

In each window
A small ration of sky.

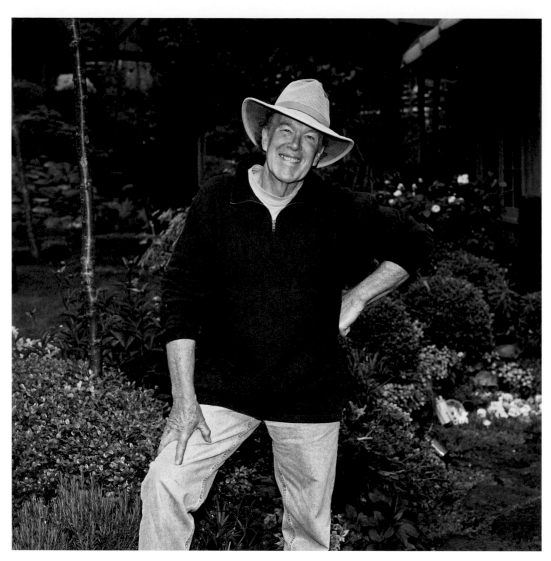

2008

DES KENNEDY

An Ecology of Enchantment,
Greystone Books, 2008

In the latter part of life particularly, but not exclusively, it is appropriate to sit quietly in a place of great beauty and be at one with it. Not looking so much, nor thinking about it, but simply being within it. Somewhere over the last decade I have come to understand that the garden is not a simulacrum of the divine, not a mere backdrop against which lofty contemplations may occur. It is itself the divine. At its best—and there's the rub, this endless quest for its perfection—yes, at its best, the garden is one of those places wherein the human spirit is set free.

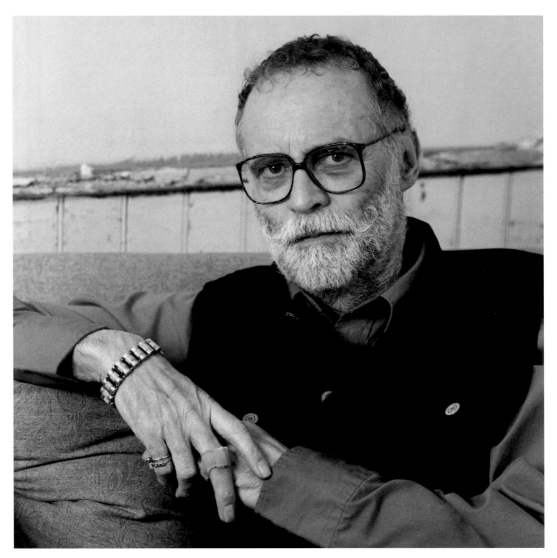

1998

W.P. KINSELLA

The Thrill of the Grass,
Penguin Canada, 1986,
and *Butterfly Winter*,
Great Plains, 2011

Quita raised her head from the lush grass and peeked over Julio's shoulder. "They have made us a blanket for the night," she said. There must be ten thousand of them on your back. Feel their warmth."

As she spoke, thousands more covered them with their gentle color.

Do they have hearts?" whispered Quita.

"I feel them beating like a million pin points," said Julio.

All that evening the shimmering butterflies covered every inch of the lovers until only the places where they were joined in passion and in love were not cloaked. They looked like burnt-orange sculpture in some erotic museum.

"They will die if we move," said Quita.

"Then we won't distress them," said Julio, and again he covered her mouth with his, as butterflies settled on their closed eyes.

And there they stayed, down all the long, silken days of their butterfly winter, Quita and Julio, entwined in love, secure under the sleek blanket of butterflies, waiting for spring.

1998

Meet Me

THERESA KISHKAN

In those years, I wish I'd known you
were somewhere. Where were you?
I lay in a hot bath and thought about dying
or else rode my horse to Prospect Lake, feeling
the world enter me, part by small part, not knowing
this would be poetry.

Where were you? I could not have dreamed
our eventual life, our children,
this rum drink with fresh lime in the heat
of August.

Van Morrison sings Meet me, Meet me, I want you
to meet me. I wanted you without knowing
you, why didn't you come
down my road where I drifted in tall grass
and rested my cheek on the neck
of my horse?

I was ready, all those years ago, to be yours.

Meet me down by the pylons, he sings
to my old self, in the old fields
that my parents have sold, the horse
of my childhood lifting his head
at the sound.

There was something you could have told me then
to sweeten those years, to take me
from that small green house by the hand,
away. Where were you? I wish

you'd have come for me then.

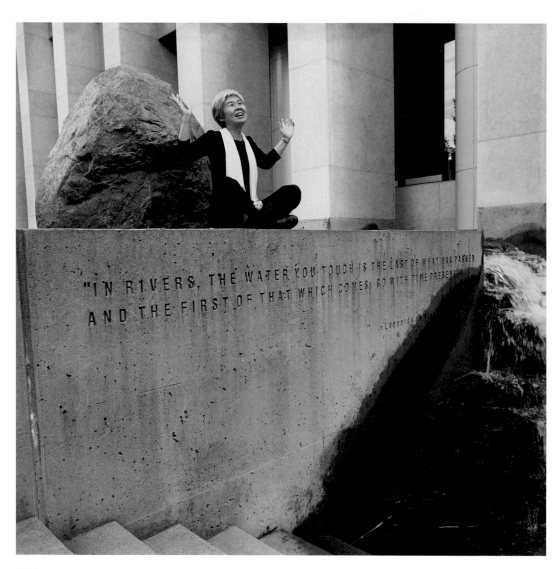

"IN RIVERS, THE WATER YOU TOUCH IS THE LAST OF WHAT HAS PASSED AND THE FIRST OF THAT WHICH COMES; SO WITH TIME PRESENT."

—Leonardo da Vinci

2000

Small Rock

JOY KOGAWA

A Garden of Anchors:
Selected Poems,
Mosaic Press, 2003

they didn't know it was a small rock
in the middle of the road
caused the bike to swerve
and hit the ditch
what was real was his being
smashed open and ambulances wailing
and everyone weeping—
the little lie was never blamed

1998

LARISSA LAI

"Nascent Fashion,"
Automaton Biographies,
Arsenal Press, 2009

exposure unknown
agent arms open
and blazing
germ in the machine

o my lovely double
elsewhere and shining
fear the manoeuvre
my biochemical package
the secret mitosis of girls
nights thick with hot paste

ancient thrall of anthrax my old
acquaintance forgot at the mere touch
down and downier
hard copy broad and helmeted
sweet winged nike
dashes for the long needle

the anecdote
to save the grand narrative

2006

TIM LANDER

A mad old man
 talks to the wind
 it answers him with an improbable question
It's been everywhere
 it knows a thing or two
 but keeps its secrets to itself
and the old man
 looking for wisdom among the stones
 for some answer
so he can get out of here
 but the wind only laughs
 it knows a thing or two
He had the answer long ago
 but left it by the road side somewhere
It is a memory
 he meets within his dreams
 that laughing flee on waking
Old man old man
 what did you know
 you're here on the shore
 marooned in the past tense
Old man old man
 go blow your Flute
 make the young women dance
 as they hurry through their day
what else is there in this fading world?
 Flowers in the trees
 and the small birds chirp
and the world awakens from a long winter
 so I play a tune or two
 on the street corner
 it doesn't mean anything
 except that I'm still here

1998

Cougar

PATRICK LANE

The Collected Poems of Patrick Lane,
Harbour Publishing, 2011

The cougar before she falls from her high limb
holds for one moment the ponderosa pine, her back
arched, her tail so still the forest stops.
There are silences to learn,
each one an invocation: the one that follows
a father's rage at a child, a woman's rage at man,
a child's tears you watch as if the sound
was a language you must learn. But a cougar's falling?
Nothing is so quiet. Even the wind stops to listen.
Beetles, busy at death, lift up their jointed legs,
whiskey-jacks slide quietly away, and ravens appear
as if they had been made out of the air.
It is to watch a thing whose only gift is death
give to herself, feeling the explosion in her heart
a thing she has made and not the men below
and not the dogs as they watch her falling
through the limbs and then erupting into sound,
their hard mouths biting what is already dead.
It is the boy on a horse so old it will not run,
a boy who watches, not understanding the men
who, when she falls, shoot their rifles at the sun,
as if with such exultance
they could bring a darkness into the world.

2005

Arson

EVELYN LAU

Treble,
Raincoast Books, 2005

Tonight the house that mocks me in my sleep
rocks in a bed of fire.
The mother is trapped in the basement,
a spider in the centre of the web,
burning to a black crisp.
The father sobs on the dark sundeck.
He is himself and at the same time,
every other man. I press my body against his
to plead for everything I need.
For weeks the landscape has been changing,
the light dying inside your office.
We are approaching the place I locked away,
the desert with its spring of sorrow,
the hollow glass heart in the core of the maze.
Doctor, I've grown afraid of noises in the night,
and the white silence of days,
and young couples on the street
pushing baby carriages
remind me of my own death.
Yesterday you gave me a hammer and nails
to destroy the wooden dresser from childhood
that appears in all my dreams, but in my hands
they changed into a match and gasoline,
and the entire house went up in flames.

2011

PEARL LUKE

Madame Zee,
Harper Collins, 2006

She stands under a Douglas fir and waits for the shower to pass, a short respite from the backbreaking work of rock picking. Since dawn she has been at it. She stoops over, loads as many stones as she can carry into a bucket, straightens, stretches, and carries the bucket to the edge of the field, where she distributes the stones in a drainage ditch. Then back into the field for more.

Her fingernails are jagged and broken, the dirt under them impossible to remove completely, even with scrubbing. If her mother could see her now, she would weep, and there have been days when she has wondered if she is mad to be here. Some of the Brother's ideas already irk her, and the work required is unreasonable by any standards, but she is withholding judgment for the moment because when she pushes past this external discontent, she has to admit that the hard labour soothes something restless within her.

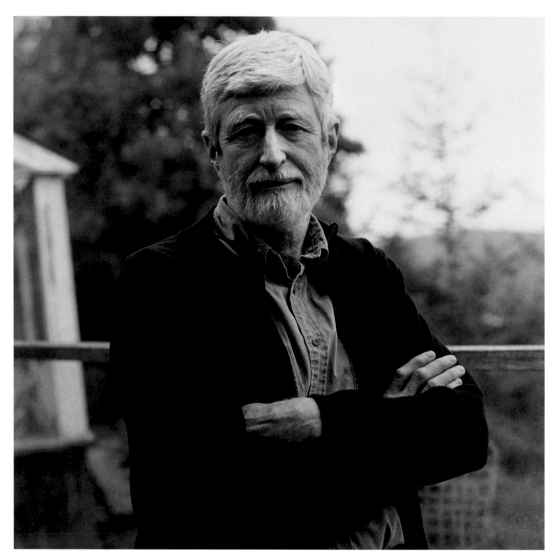

2011

DEREK LUNDY

The Bloody Hand:
A Journey Through Trust,
Myth and Terror in Northern Ireland,
Knopf Canada, 2006

Both Alexander and his province demonstrated morbid symptoms. If the unionist Northern Irish state had been a person, a diagnosis would have been comprehensive: deeply neurotic (anxious, obsessive behaviour), fundamentally sociopathic (lack of moral responsibility and social conscience), and episodically psychotic (loss of contact with external reality). Alexander was equally complicated, a solitary, melancholy man, hard to know or touch. Like all sons, I wanted my father to be as the Ulster poet John Hewitt describes his: "the greatest man of all the men I love." But Alexander and I could never make that bond. He became lost in his own sadness, absorbed in his fight to avoid a terrible and long-prefigured breakdown and depression. It effloresced when he was forty-four and could no longer stave it off, and it went on for years. Even a son beloved in a way could only loiter on the fringe of such an obsession with mere endurance.

2005

Spring Fever

VERA MANUEL
1948–2010

Today the sun came
shining through the cold,
relentless it barged
through every space and crack
around the blinds.

Even with my eyes tight shut
it kept right on playing with me.

I growled like a bear,
turned away, rolled over,
then over again,
burrowed my eyes
into the sheets,
hung stubbornly onto sleep
and grumbled:

"Oh quit, you're only teasing me.
I know the minute I get up
get dressed
get raring to go
you'll disappear,
just like you always do
behind the nearest
vapid dark cloud
that seduces you
and then where will I be?"

Ooh that old Sun, he wouldn't quit
he just went right on
making sweet love to me.

Daphne Marlatt and Suka, 1998

For Suka

DAPHNE MARLATT

Grass words green up & wither
love - fur - lick in pleasure liking
the contrary ache of the quick

across that gap where other & open
reopen a moment too
presently gone

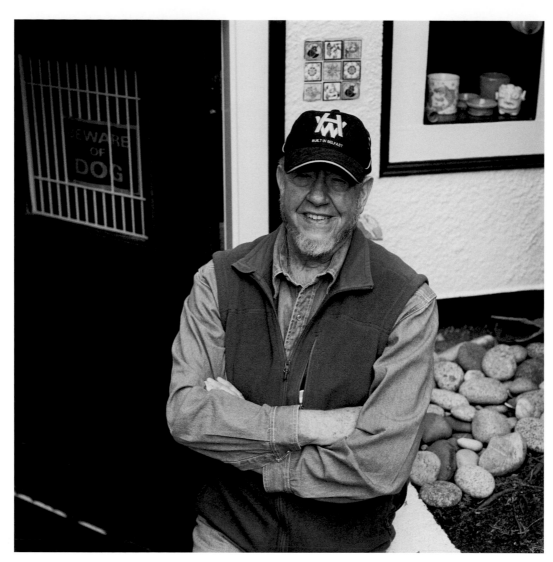

2011

GEORGE MCWHIRTER

Clouds come off the trees, then off puddles on the road when the sun comes out. Steam off the puddles reaches the tops of the trees and braids with the cloud from the trees as the wind moves the enfolded formation out over the water. Over the surface of the water, the clouds weft and drift into clear relief: dark and pale grey as your winter face: the finer the cloud, the frailer the grey. Walkers huddle under hoods until they are moved to pull them off and let the light at their faces. The orange tarp steaming through the trees, the orange ribbons, tied to the trees to mark the trail to the camp are noted by those who fear to follow those ties to the camper in the orange slicker, who steams as the sun falls on his back and the sun's orange glow swallows the flames of his camp fire, from which his eyes drift, pale grey-blue as the sky with clouds clearing slowly over.

He lives in the wood in an orange womb, which might derange you to look into. You walk around it, deceived, if your destination is a door to a dry life inside while he conceives a climate change each time he peels the orange tarp off his counter-revolution.

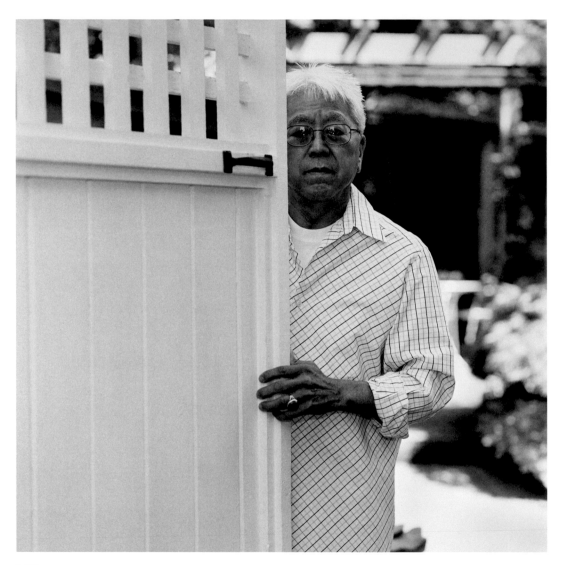

2009

ROY MIKI

"A Walk on Granville Island"
Mannequin Rising,
New Star Books, 2011

These consumers in motion
have no name tags no ids
to drift off to dreamland
in a carnivalesque pitch
that cannot be notated

It could be that a walk
along the seawall arrests
the detached thought
keeps at bay the resilience
of thighs and the canvas

Let the rain mosey down
the waterproof garments
in a canopy of charms

It's not so foolish to stoop
over the edge of the pier

Not so foolish to brain
storm the refracted light

2005

ALICE MUNRO

"The Epilogue, Messenger,"
The View from Castle Rock,
McClelland & Stewart, 2006

Now all these names I have been recording are
joined to the living people in my mind, and to
the lost kitchens, the polished nickel trim on the
commodious presiding black stoves, the sour wooden
drainboards that never quite dried, the yellow light
of the coal-oil lamps. The cream cans on the porch,
the apples in the cellar, the stovepipes going up
through the holes in the ceiling, the stable warmed
in winter by the bodies and breath of the cows—
those cows whom you still spoke to in words
common in the days of Troy. So—boss. So—boss.
The cold waxed parlour where the coffin was put
when someone died.

 And in one of these houses—I can't remember
whose—a magic doorstop, a big mother-of-pearl
seashell that I recognized as a messenger from near
and far, because I could hold it to my ear—when
nobody was there to stop me—and discover the
tremendous pounding of my own blood, and of
the sea.

2008

SHEILA MUNRO

Lives of Mothers & Daughters: Growing Up with Alice Munro, McClelland & Stewart, 2001

I know I am on dangerous ground here. I tell myself I am wrong to see fiction in this way, that fiction, even autobiographical fiction, is not the same as autobiography, but I can't change it, I can't unravel the truth of my mother's fiction from the reality of what actually happened. So much of what I think I know, and I think I know more about my mother's life than almost any daughter could know, is refracted through the prism of her writing. So unassailable is the truth of her fiction that sometimes I even feel as though I'm living inside an Alice Munro story. It's as if her view of the world must be the way the world really is, because it feels so convincing, so true, that you trust her every word.

Chelsea Hawthorne, Susan Musgrave and Sophie Reid, 1998

SUSAN MUSGRAVE

My work is an escape.
It expresses my True
Feelings about the
Meaning of Life.

My writing is a
Reflection of my Soul,
And my struggle to be
released back to my
family.

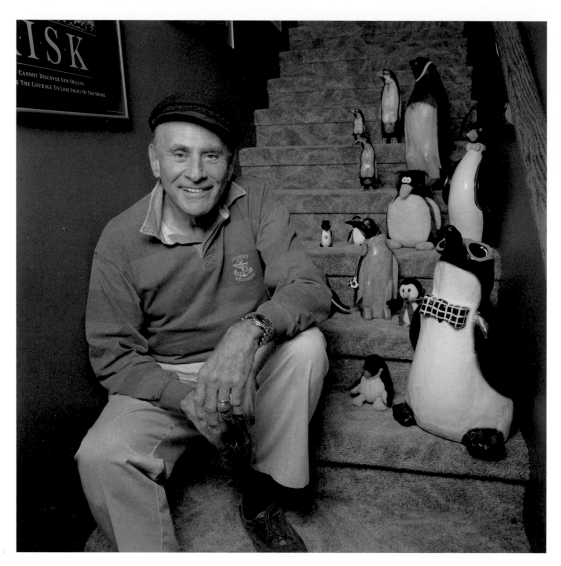

1999

PETER C. NEWMAN

As a writer I have always empathized with Don Quixote's struggle against "the melancholy burden of sanity." To be a writer in these cold latitudes requires more than a slight dose of madness. Yet it is a life also filled with the grace notes of self-discovery and, every once in a while, a near-perfect paragraph...

1999

ERIC NICOL

1919–2011

Oh-oh, humorists should never get photographed grinning. It looks pushy. Woody Allen, greatest humorist of our time, has never been shot with a smile on his face. He doesn't need it to sell his stuff. Woody can appear as what he is: basically miserable. Whereas this guy waffles. What a luxury, to have genius!

1999

to seek

BUD OSBORN

45 years old
broke and homeless
and waking up
like death warmed over
in another detox bed
breathing pain
each drop of sweat
hopeless
but for one long bewildering moment
hunger
rose like a flood below my bed
hunger
burst into flames in the air above
hunger
deeper than my shrunken stomach
hunger
howled out
and left me burdened with
appetite

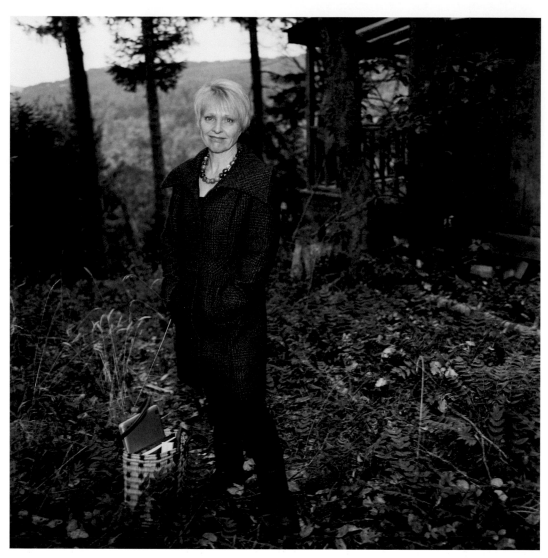

2011

KATHY PAGE

As in Music and Other Stories,
Methuen, 1990,
and Phoenix, 2009

I spent twenty-nine days alone in the Gobi desert;
I've got a pilot's licence; I've tickled the soles of the
feet of the Dalai Llama for nearly an hour and,
believe me, he didn't move a muscle. I've been in
three movies, but you won't have seen them—it was
in Turkey. I lost half a million at cards—wasn't mine,
but it would have been if I hadn't lost it. Easy come,
easy go. Look at my arm! It was done in Hong Kong
by a bearded lady. Took forty hours. And look at the
muscle, too. I took cyanide in a hijack death-pact and
came to just as they were about to bury me. I didn't
do much in the antipodes—too burnt out. Lived in
a cave, had a baby, joined a theatre group. Then I
met the Sheik—

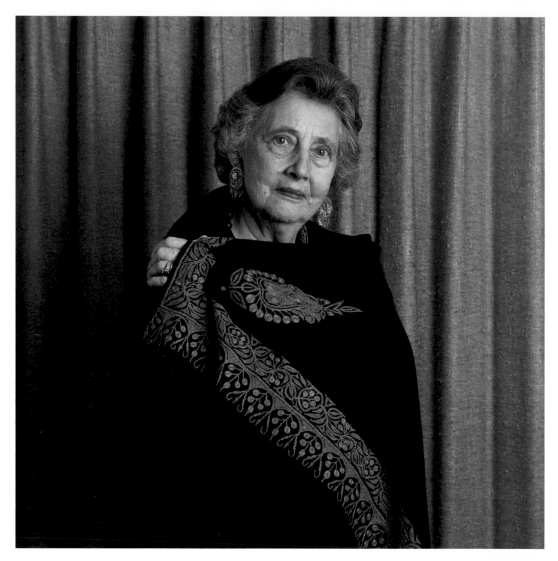

1999

Single Traveller

P.K. PAGE

1916–2010

Visions and Revisions:
The Poet's Process,
Broadview Press, 2002

What is this love that is my life's companion?—
shape-changer, sometimes faceless, this companion.

Single traveller, I wander a wasting world
awaiting the much anticipated Companion.

A trillium covered wood one April day
served as a nearly consummate companion.

A horse, two dogs, some cats, a blue macaw
each in its turn became a loyal companion.

Behind the loved embrace, a face of light—
demon or angel—lures me from my companion.

The street of love is neither wide nor narrow.
Its width depends on me and my companion.

Am I too bound and blinded by coarse wrappings
ever to know true love as my companion?

O Poet, squanderer of time and talents
why do you search for love as your Companion?

Ken MacDonald and Morris Paynch, 1998

After all this time. Who wants to know there's no one in charge of things? It leaves us with nobody to complain about. When things go wrong. As they so often do. But one does wonder when they're going to show up—these absentee proprietors. I'm staying only as long as that.

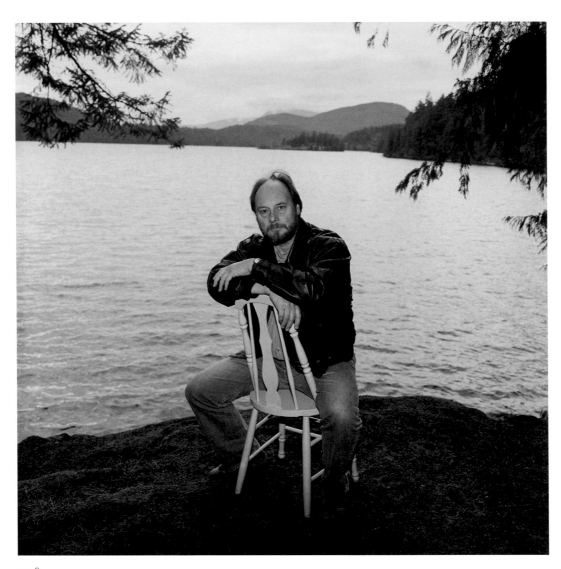

1998

Sea Blush

JOHN PASS

Water Stair,
Oolichan Books, 2000

No poem in May
so late in our love affair
with the earth, that battered marriage

can be entirely shameless, fearless
to do her justice, presuming to extol again
redundant beauty. Quickening even so

in the sudden names, seasonally
forgotten, spoken afresh, it whispers *speedwell*
to the miniscule blue-white sparks on the path

or leans in with a sliding touch
to the long cool muscle of arbutus
(a steadying hold, crouching lower)

to see up close the mauve-pink flower
awash in masses over the moss bluff
meadows near the water.

Tongue in her name each sundering first time
at sundown her look catches sea's deep colour

in a held breath recklessly lingers.

1997

Homo Bores Me

STAN PERSKY

Autobiography of a Tattoo,
New Star Books, 1997

Once, half a lifetime ago, homo was imperative
as a source of knowledge, frontier of information,
fountain of good gossip. Now homo wants to
marry, collect spousal benefits, adopt kids, be a
good consumer. I've nothing against any of that,
but it bores me.

Once homo thought: Desire is nature, and thus,
almost by definition, playful, anarchic, out[side]law,
subversive of conventional society; now homo is
content to put on its slippers, domesticate desire,
join the Rotary Club. If homo ain't interesting,
I ain't interested.

1999

AL PURDY

1918–2000

"A Handful of Earth,"
Beyond Remembering:
The Collected Poems of Al Purdy,
Harbour Publishing, 2000

Sod huts break the prairie skyline
then melt in rain
the hip-roofed houses of New France as well
but French no longer
nor are we any longer English
—limestone houses
lean-tos and sheds our fathers built
in which our mothers died
before the forests tumbled down
ghost habitations
only this handful of earth
for a time at least
I have no other place to go

1998

MEREDITH QUARTERMAIN

A photograph, writing by light, radiant energy
inscribed in silver chloride and bromide,
refracted through glass, through pourings
from beakers of chemicals, the aqueous
humour, the lens, bending rays, breaking
open . . .

Vision, in Sanskrit vid, is to know,
as in English wit, as in Latin videre,
from which comes advise, devise, revise,
provide, survey, purvey, envy, invidious,
evident, and provident.

1999

My Friends

JAMIE REID

I. Another.
The Space Between:
Selected Poems,
Talonbooks, 2004

Easy enough and sometimes half-deliberate,
to forget and to dream. Memory will often evaporate,
leaving not even a trace of some steam.

Then again, it is always returning, differently dressed,
in an altogether altered light, claiming an entirely
different set of relations and friends.

Stephen Reid and Sophie Reid, 1999

Stephen Reid: Bank robber, Dad

STEPHEN REID

There is no way to prepare for either of these roles, it's strictly on-the-job training. When I first traded my gang for family it didn't take me long to wake up to the fact that in parenting, like in bank robbing, at first you get lucky then you get good. I tripped over some other similarities...

You are always nervous about your first one.
Both involve frequent trips to the bank.
There will be moments when it's wise to wear a mask.
Timing is everything.
So much depends on having the right partner.
Each carries a sentence of life.

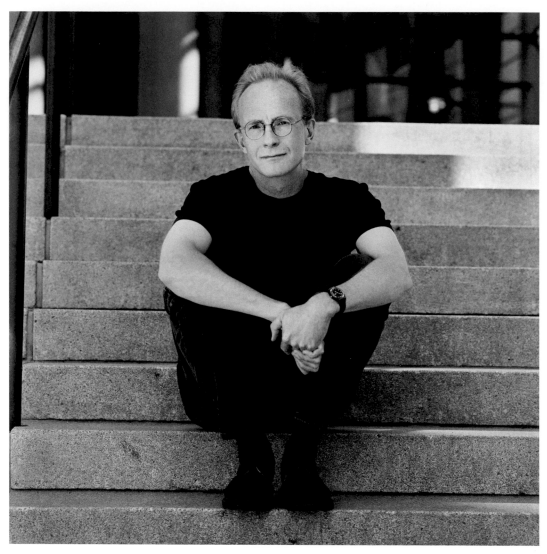

1998

BILL RICHARDSON

When I was a little boy, I loved the poems by A.A. Milne in *When We Were Very Young* and *Now We Are Six.* I still love them, come to that, especially "Halfway Down."

> Halfway down the stairs
> Is a stair
> Where I sit.
> There isn't any
> Other stair
> Quite like
> It.
> I'm not at the bottom,
> I'm not at the top;
> So this is the stair
> Where
> I always
> Stop.

Probably this appealed to me because I was the second of three sons, and I warmed to any suggestion that being stuck in the middle was a tenable, even a desirable, position. Now we are no longer young. Now we are 46, or nearly. Now, the poem takes on a darker resonance. Half in sun, half in shadow, the step I straddle is equidistant between beginning and ending. This much is certain, though it's not at all clear to me whether I'm on the ascend or the descend. Time, our one true indefatigable, will, I suppose, tell.

1998

LISA ROBERTSON My purpose is to advance into the sense of the weather, the lesson of the weather. Forever I'm the age 37 to steady my mind. I'm writing sentences here of an unborrowed kind. The sky is mauve Lucite. The light lays intact and folded. You can anticipate the wind. A slight cloud drifts contrary to the planet. Everything I'm writing about begins.

2011

Your Dream

AJMER RODE

Poetry International Web,
June 30, 2008

If you have forgotten your dream
don't worry
I saw it with my own eyes

The figure that stood before you
with a bouquet of fresh roses was
not me
The arm that wrapped round your
waist was not mine, nor the fingers
that stroked your long hair

The umbrella that suddenly escaped from
your hand, disappeared in the sky
was me
leaving you free in the rain
to walk laugh run and slip
before you woke

2000

LINDA ROGERS

The next door neighbours object to our wild garden.
On holy days, Lawnboy mows defiant squares and
his wife throws morning glory over the fence. When
they look in our irregular windows, they see me
smoking Esplendidos in my Sunday dress, while the
king of vibrato paints my toenails red.

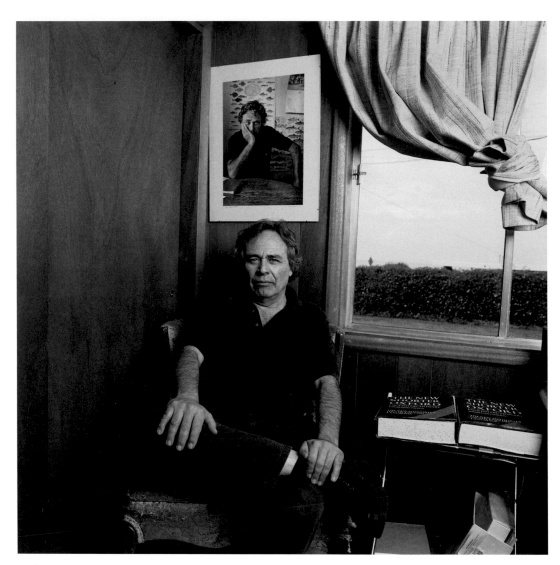

1998

Who Am I?

JOE ROSENBLATT

The body desires the cover of anonymity,
the cover of darkness, the robe of iron silence.
It desires, feels the enclosures, the sullen weight
of eons, the deadening of all the nerves.

No more cloudy cowish eyes, moons of embarrassment
no more stings of light-weight tarantulas
caresses of scorpions, or the coup de grace of queen bees.
It's nearly over, the sands of mediocrity fall
before the tide of freezing truth, before the fingers
of the human octopus rape the whole reality

the reality is repetitious, its soil is barren
nothing will grow in it but repetition –
the lies have returned to the dirty nest.

1998

JANE RULE

1931–2007

It is not the length but the quality of life that matters to me, more easily said now that I am over fifty. But it has always been important to me to write one sentence at a time, to live every day as if it were my last and judge it in those terms, often badly, not because it lacked grand gesture or grand passion but because it failed in the daily virtues of self-discipline, kindness, and laughter. It is love, very ordinary, human love, and not fear, which is the good teacher and the wisest judge.

2011

MAIRUTH SARSFIELD

No Crystal Stair,
Women's Press, an imprint of
Canadian Scholars' Press, Inc.
2004

For the next half hour, he faithfully followed the Orthodox exhortation, telling the pair what the sacrament of marriage consisted of and how they ought to love God . . .

Downstairs in the church kitchen, Amelia Hall fretted. It had been forty minutes since she'd put the blasted Russian salmon pie in the oven . . . "Bake the . . . koolybakky one hour in a 400-degree oven. Serve at once with a pitcher of sour cream. How can a body be expected to time the servin' of this here foreign food when that foolish woman won't agree to a proper ceremony? How kin Ah serve it crisp and hot," Amelia asked the stove, "when in twenty minutes that pie will begin to overbake?"

"All this foolishness! What's wrong with good ole-fashion' Baptist vows." Amelia lifted the lid on her shrimp gumbo. "Sweet Jesus, these shrimps will be cremated if the ceremony goes on any longer!" . . . Moving the sweet-and-sour lamb ribs to the back of the oven, Amelia added a cup of whiskey to the gravy for the fried chicken . . .

"Enough is enough!" Resolutely, Amelia removed the lids from her bubbling pots, carried the powerful spiced gumbo casserole to the air vent that wafted warm air up into the chancel. "Sweet Jesus, forgive me!" she intoned. On the stairs leading up, she placed three pans of simmering cinnamon-spiced, brown-sugared sweet potatoes. Under the choir's air vent, she lit a match to the rum sauce, initially intended to be poured over the deep-dish bread pudding dessert.

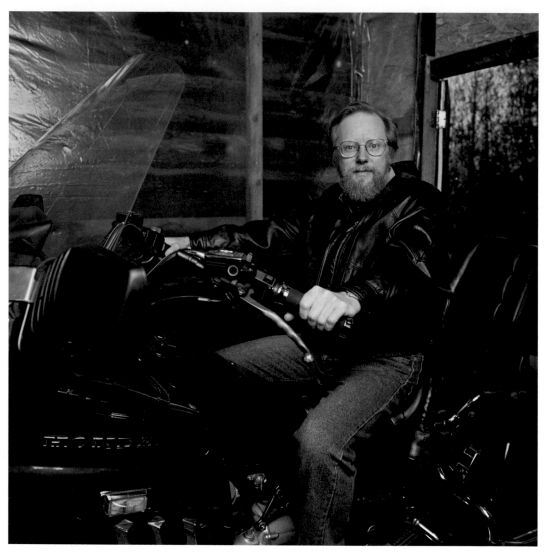

1998

File of Uncertainties #4

ANDREAS SCHROEDER

File of Uncertainties,
Sono Nis Press, 1971

All night I dream snow;
In the morning, an avalanche
deep inside myself
shakes me awake . . .

All day, the endless falling
of rocks and snow
through the brain.

My mind already accustomed
to move with swimming motions
constantly.

This year, the winter of me
is no longer distracted
by the craft of the snow-cannon.

How many times my history has been
deluged, dug out, rebuilt,
I no longer know,

But this remains: always
in the ensuing silence,
the scrape and sigh
of distant
shovels.

1999

My Drum, His Hands

GREGORY SCOFIELD

Love Medicine and One Song,
Kegedonce Press, 2009

over the bones, over the bones
stretched taught
my skin, the drum

softly he pounds
humming

as black birds dance,
their feathers
gliding over lips, they drink
the stars
from my eyes
depart like sun
making way for moon
to sing, to sing
my sleeping

my sleeping song
the sky bundle

he carries me to dreams,
his hands wet
and gleaming

my drum aching

2000

Hornby Island

for Billy Little who shared loved spots and fond friends

GOH POH SENG

1936–2010

Here on the headland by Downe's Point, we cast
dreams to rise synchronous with eagles and gulls,
all make-believe, egocentric, near to fanatical, else
aim true to roam deep with Leviathan in the ocean's
mind, free from perplexities and profundities such
as bind the scheduled self. Here in the arbutus grove
whose trunks and branches tighten like nerves,
twisted witnesses, victims of shapely winds which
blow in always unseen, sweet from the south or
coming cold from the north, from every direction
the prevailing force of nature. Wish I could emulate
the arbutus, slough off my thin skin as easily as
these native trees their bark from abrasion, disdain
or design, unveiling the bare beauty of strong, hard
wood beneath. Over on Fossil Bay, the rot of herring
roe strewn amongst broken clam shells, dead crabs,
on dirty grey sand, exposed bedrock, thicken the
morning air, but gave no cause for bereavement:
these millions of botched birthings! And none also
for the Salish, no open lamentation for a race almost
obliterated without trace from their native habitat,
save a few totems, some evidences of middens, a
score of petroglyphs of their guardian spirits carved a
thousand years ago on smooth flat rock by the shore,
of killer whales, Leviathans again, to guide their
hunts, the destiny of their tribe. Having retraced
them gently with finger tips, they now guide mine.

1999

When required these days to fill out some Form demanding to know what I do in the world (my occupation) I will sometimes give myself partial identification as "writer" and it is true that I have written three books. But of course that alone does not entitle me to label myself as a writer since writing is not what I am driven by temperament to do and I do not write out of a compulsion to clarify my thoughts, or to give voice to my dreamings and imaginings. Still I tend to think of writers as special people and I am pleased as here to be included in their august company.

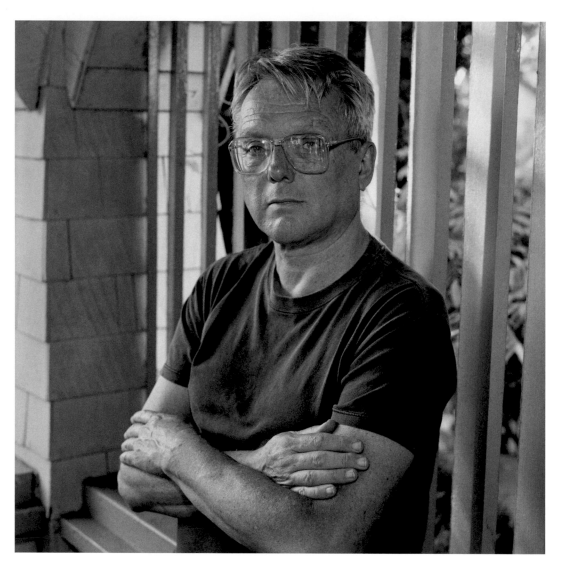

1999

Family Eyes

GEORGE STANLEY

Whether by blood or mere authority,
this knowledge: eyes look out of an awful
lostness.
 Lost & found on earth, together.

The eyes of friends are beautiful jewels.
The eyes of lovers are perilous mirrors.
Family eyes scope the skulking soul.

2005

ROBERT STRANDQUIST

"The Shift," *A Small Dog Barking*,
Anvil Press, 2005

Janitor stands on the roof of the old gym looking through his telescope at the bridge. He studies the jumble of dwellings beneath it, the stacked busses and sideways containers, the spaces between them where maybe another thousand live. Steam rises from openings with the stench of distilled spirits, which from this distance he can't smell, though they blow far enough on memory's breeze. Perspiring a thin layer of rust, the eternal towers adorned with graffiti are draped in rope ladders and fishing nets. An ancient superhero is climbing the web unrehearsed, high above the deck, high above the dried-up harbour, making for the top of the southeast tower. Or is this one supposed to be a bird? A mob will have gathered on the mud flats below, others hanging off the superstructure to watch. It's the only theatre in town. The Greeks and the Elizabethans and the absurdists all squeezed into one short performance. If it was a good one somebody might do the honourable thing and dig a shallow grave. Janitor wants to shut it down, plug up the holes, put the stills to better use. Clean water he could trade for shrooms, or poor quality speed. Escape is more valuable than gold. More valuable than escape is cancellation, with its headless glimpse of reality, and only ganja can do that. But it takes water to grow weed and that makes it the rarest of the rare.

2011

PETER SUCH

In 1898 my Jewish grandmother was given this French Ormolu clock with Sevres porcelain plaques as a wedding present. Its statue of Liberty, a common theme after 1789, is about to release a carrier pigeon "with a message of peace to the world," she would say (having gone through two world wars).

On holidays from my orphanage I loved listening to the silver bell chime as she moved the hands around the dial as she told me my father had done. He was killed in 1944, flying air-sea rescue.

When Nana died in 1951, "The clock stopped, never to run again" as the song goes. It came with me to Canada in 1953. Since then, it has gone from mantel to mantel, always treasured and admired, never restored, bits of rococo decoration breaking off, its silver bell stolen.

When this photo was taken, the pendulum swung and, sitting on my lap, Nana's clock began to tick again after sixty years. That's why I am laughing.

Since then, around the clock, I've been wondering. What am I supposed to do about it?

2011

GEORGE SZANTO

The Underside of Stones,
xyz Publishing, 2004

Dead. I knew he was dead, I'd helped put him in the ground.

An honour for any gringo, my neighbour Pepe told me. Except I hadn't understood the dead man's son Tomás nearly well enough to grasp the nature of this honour.

Tomás was the eldest. "My father willed it."

You don't argue with the eldest son of a dead man, not after less than three months in a town and your sweeper dies and the responsible son says you are a pallbearer. Despite too much recent contact with death, you go.

I'm here in Mexico trying to write a novel. But the dead man, my sweeper, often interrupts. "You would like a story? I have a few little stories." After he was dead he told me, There are hundreds of stories going on under your nose. But you gringos are blind.

He's much ruder dead than alive.

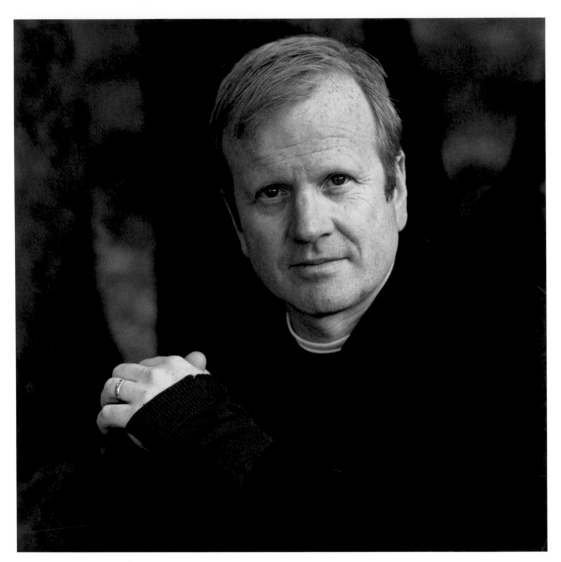

2011

TIMOTHY TAYLOR

The Blue Light Project,
Knopf Canada, 2011

Like they were acting something out. Like they were part of the show.

They escaped by the rear doors of the television studio. Mad crowds, crazed. Adults and children. They slammed into each other and bounced, they grabbed each other and held, or pushed away. The only law governing their movement was the impulse to escape. To get out, get free. In that they were inspired by one another. Pushing and pulling, helping and not helping. The concrete stairs echoed on the way down, feet stamping and skipping and slipping. Some people were on their cell phones already, but there really wasn't anything to say. They didn't know anything, nobody did. So close were the performance and the feared reality, so close the entertainment and the violence.

So they yelled into their phones: A man with a gun! But they also added other things, voices scrambling out the words: As if he had been choreographed! Just like it were part of the show! And they forwarded pictures and video clips too, out there in the rear alley and the side street, but these images didn't reveal anything. Grainy figures in black, curtains of smoke. Terrible audio. They were dream sequences.

1998

SHARON THESEN

Aurora,
Coach House Press, 1995

My car I drive back & forth
around the town over bridges & here
and there, like everyone else
driving their cars. In the back seat
sits the ghost of your grandma.

1998

Through the Apricot Air

PETER TROWER

Haunted Hills & Hanging Valleys:
Selected Poems, 1969–2004,
Harbour Publishing, 2004

A poet is dreamfooted and walks a curious tightrope
his song rises strangely through the apricot air
love is his joy his tool his wisdom his folly
he circles mothlike and the candleflame truth of things

He strikes from nothing the sparks of what ought to exist
the knowledge aches out of his eyes creation's his purpose
he scrawls on the sky inhabits the lunatic corners
in the web of delusion he crouches, alert as a spider

A poet is a decoder of arcane messages
received on the crystal set of his eavesdropping heart
from the scrabble-bag of letters he plucks the singing images
threads them like beads on the lines of his secret longing

He is a cardsharp of words that sting and praise and wonder
his mind swings erratically between micro and macrocosm
he studies the eccentric comings and going of house finches
and the ghostly pillars that whelp stars at the edge of the universe

A poet is a brief mad seer in a sea of bottomless mysteries
he is driven more by curiosity than wisdom
he lives his life by luck, intuition and chance
and leaves as his legacy only a random scattering
of delirious verse.

1998

ALAN TWIGG Scientists have yet to discover the cranial expression of optimism that is induced by sleeping to persuade us to gallantly leave the safety of our beds with all the foolishness of soldiers leaping from trenches.

2011

FRED WAH

First Chapter:
The Canadian Writers
Photography Project by Don Denton,
Banff Centre Press, 2001

Play. I keep reminding myself to let go of the sentence (don't get sentenced to the sentence), that know-it-all that wants to tell it all. Play around within the word, between the words. Look at what's left over after grammar. And, I'd tell my younger self, this is serious play, this improvisational fun between the words and syllables and letters and, finally, back inside the sentence too, that this is what turns writing into discovery and into consequence. When I was starting out as a writer, one of my teachers asked "Why bother"? Now I know why and how to bother; words can and need to make a world. But don't try too hard. I'd tell myself to let go of intention, to go against the grain, and be open to the other, to the differences. And listen. Play it by ear. Now I'm older I can listen to the younger and I hear them play around and stumble on things; let a blunder be a blender, say, let a picture be aperture.

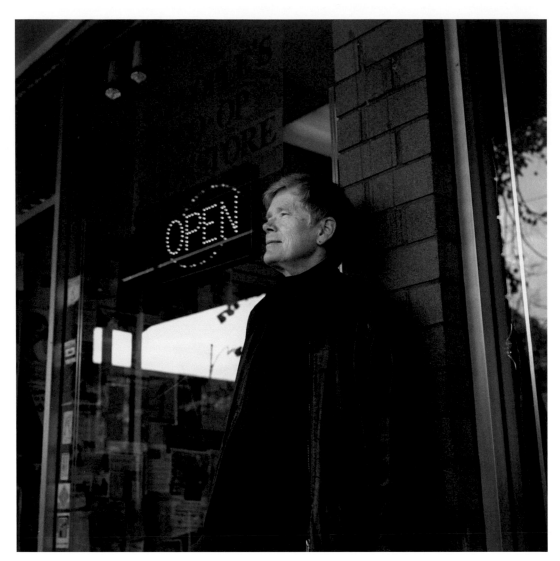

2011

BETSY WARLAND

Bloodroot:
Tracing the Untelling of Motherloss,
Second Story Press and Summach Books, 2000

The more I write out of my life, the more I encounter the impossibility of telling the truth.

The lived story is far more complex than the fabricated one. This is the seduction of fiction: its containability. The certainty of words black & white on the page. The comfort of no one else's version calling ours into question. That sad yet sweet satisfaction when "The End" used to appear on the last page.

I had assumed autobiography to be an inscribing of identity. Suspected it to be an amplification of ego. It is quite the opposite. With every word I write I am reminded of deficiency. Incompleteness.

Every word I select is at the expense of others.

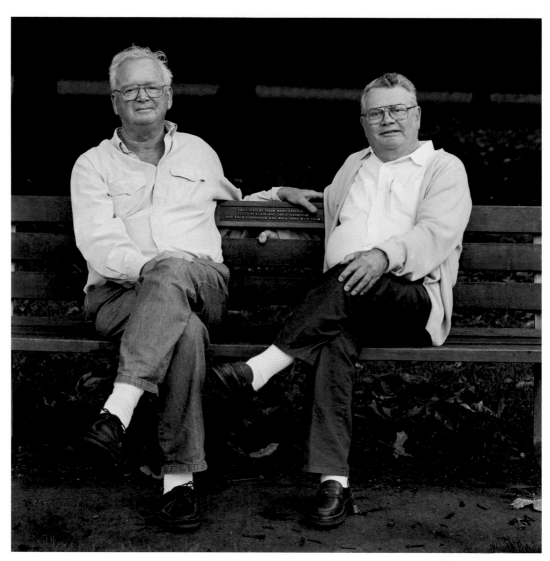

Floyd St. Clair and David Watmough, 1997

The Park Bench

DAVID WATMOUGH

It has always begun for me with the open air. The initial magnet of Paris was a place where I could write at a sidewalk café. The Seine-laced city where we first walked and talked along so many gravel vistas friezed by scarlet salvia under sun and cloud, through the wind and the rain of four seasons...

Vancouver—where the steely sinews of our Paris-forged love have turned tungsten; where my fictional muse was first sparked in monodrama and then endlessly fructified in stories and novels over three decades in the briny and log strewn environs of Kitsilano's beaches and the soft southwesterlies gently combing the fronds of willows across her parks and avian streets.

So now we harbor on our Jericho bench; two old men feeding on autumnal sunlight and delighting in swaying cattails and trees in ochrered competition with their fall foliage. Two old gents dreamily lost in the lyricism of fifty shared years and the comforting rhythm of seasonal leaves spiraling from deciduous trees.

But we still look outwards to the uplift of mountains, nurtured and nourished in a shared vision as life still prods and probes evoking the murmur of fresh words, the energy of complaint against injustice and imbecility, the joy of next-door babies and the unerring comfort of such friends whose bench inscription binds us. In our mutual support we greet you as we feast on a daylight moon and the promise of comets and stars.

1999

PHYLLIS WEBB
———————

"Imprint No. 3",
Hanging Fire,
Coach House Press, 1990

In the floating world
she stands quite still
like the snowy heron
who is really always moving

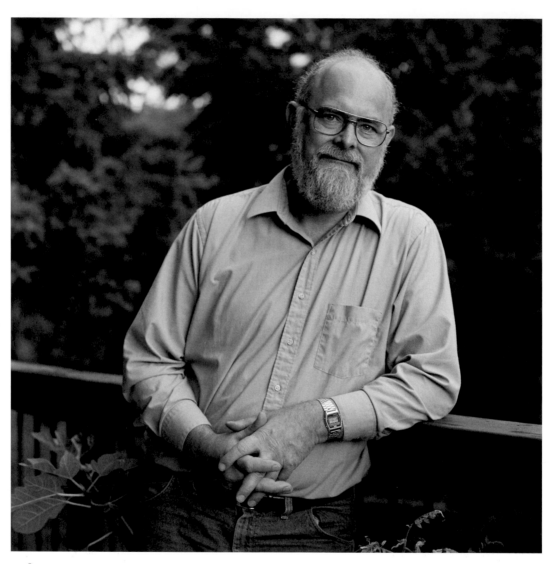

1998

Writing in the Rain:

HOWARD WHITE

Writing in the Rain,
Harbour Publishing, 1990

I've actually done that, write in the rain. I could tell you a lot about it, sitting out on a road grade on a spreading machine waiting for the next turn, hunched over a piece of notepaper folded down to vestpocket size, scratching down thoughts in shorthand as rain drips off the end of your nose, raising a spongy welt on the paper and then the ballpen won't stick. At the end of the job I'd have this little pile of exceedingly dirty folded-up notepapers covered with indecipherable chickenscratch . I still find them floating around the house, although I write in the rain only rarely now. I've got rainstained notes from the Rainbow Lake oilfields of Northern Alberta and the muddy sidehills of Vancouver Island above Port MacNeill. I've got them from Delta dyke jobs and lots from the garbage dump detail in Pender Harbour. Most contain wonderful plans that I might yet follow up if I lived to be a hundred and one, some contain the germ that later developed into a story or a poem.

This is where writing has always been for me, wedged uneasily between the world of gravel, logs, ringing phone and the other, equally demanding world inside. Like all interfaces, all borders, it's a precarious place to set up one's shop, but it's also a place where interesting things happen, a frontier.

1999

RITA WONG

"pandora street"

i walk down the street a lone asian woman
a loaded act
tender as gentians subtle as spring
when the wannabe pimps come knocking
i'll be out dancing with the girls

2008

CAROLINE WOODWARD

This is me, barely suppressing glee and joy. Restraining a great, wide grin which would unleash a whole lot more laugh lines (that I'm not quite ready to face the world with yet, Mr. Hasselblad Photographer).

This is me, looking ahead to writing full-time at long last, working on my own dreams, my own stories and poems and plays and essays, no longer burdened with the chattering, exhausting necessity of my day-job. There is a light at the end of my Tunnel of Delayed Gratification.

This is me, with a glint in my eyes, thinking of my lovely, furry lightkeeper husband, who is every bit as much of dreamer and artist as I am. He is my true soul-mate and I am his and we are blessed with each other and with our fine sailor son. We have been too long apart but soon, soon, we'll be walking arm in arm like the aging lovebirds we are.

This is me, looking forward to a good ramble around the lighthouse island, scanning the ocean and sky, hoping for whales or peregrine falcons, cheering on the surfing sea lions, noting the ripening salal berries on the south-facing slope, thinking of the salal berry & apple crisp dessert we invented on Egg Island, Summer of 07.

This is me, so grateful to be alive on this planet, knowing I will, once again, fall asleep while the humpback whales sigh and swoon as they circle our island. Soon, soon.

2011

RONALD WRIGHT

A Short History of Progress,
House of Anansi, 2004

Humans have made their way in the world so far by trial and error. Unlike other creatures, we have a presence so colossal that error is a luxury we can no longer afford. The world has grown too small to forgive us any big mistakes.

 BIOGRAPHIES OF AUTHORS

Vancouverite **CAROLINE ADDERSON** is the author of three novels (*A History of Forgetting, Sitting Practice, The Sky Is Falling*), two collections of short stories (*Bad Imaginings, Pleased To Meet You*) and numerous books for young readers. She has won the B.C. Book Prize's Ethel Wilson Fiction Prize twice, the CBC Literary Award three times and the Marian Engel Award for mid-career achievement. She lives in Vancouver.

TAIAIAKE ALFRED is the Director of the University of Victoria's Indigenous Governance program. Born in Montréal in 1964, he was raised in the Kahnawake Mohawk Territory. He served in the U.S. Marine Corps as an infantryman during the 1980s and lived in Kahnawake until 1996. He now lives on Snaka Mountain in Wsanec Nation Territory on the Saanich Peninsula with his wife and three sons, who are all Laksilyu Clan of the Wet'suwet'en Nation. His books include, *Peace, Power, Righteousnes: An Indigenous Manifesto* (Oxford University Press, 2009)

Who says love can't be found at a bus stop? **JULIE ANGUS** and **COLIN ANGUS** met while waiting for public transit in 2003, and since then have combined their passion of exploring the world using human-powered modes of transportation. They jointly received National Geographic's 2007 Adventurers of the Year award and are best-selling authors who have collectively written five books published around the world. Their films have been aired on National Geographic Channel, CTV Travel and others.

256

Sheila Munro, 139

Susan Musgrave, 141

Peter C. Newman, 143

Eric Nicol, 145

Bud Osborn, 147

Kathy Page, 149

P.K. Page, 151

Morris Panych, 153

John Pass, 155

Stan Persky, 157

Al Purdy, 159

Meredith Quartermain, 161

Jamie Reid, 163

Stephen Reid, 165

Bill Richardson, 167

Lisa Robertson, 169

Ajmer Rode, 171

Linda Rogers, 173

Joe Rosenblatt, 175

Jane Rule, 177

Mairuth Sarsfield, 179

Andreas Schroeder, 181

Gregory Scofield, 183

Goh Poh Seng, 185

Doris Shadbolt, 187

George Stanley, 189

Robert Strandquist, 191

Peter Such, 193

George Szanto, 195

Timothy Taylor, 197

Sharon Thesen, 199

Peter Trower, 201

Alan Twigg, 203

Fred Wah, 205

Betsy Warland, 207

David Watmough, 209

Phyllis Webb, 211

Howard White, 213

Rita Wong, 215

Caroline Woodward, 217

Ronald Wright, 219

Rachel Wyatt, 221

Max Wyman, 223

Patricia Young, 225